# LLANDUDNO AT WORK

## PETER JOHNSON

AMBERLEY

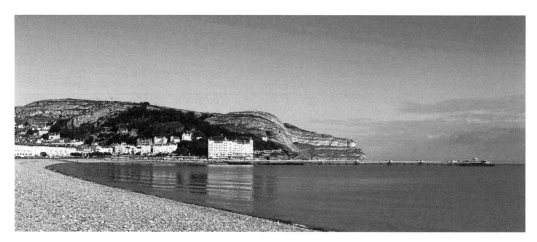

Llandudno Bay.

*For Charles Eaves and all the chaps for their support.*

First published 2018

Amberley Publishing
The Hill, Stroud
Gloucestershire, GL5 4EP

www.amberley-books.com

Copyright © Peter Johnson, 2018

The right of Peter Johnson to be identified as the
Author of this work has been asserted in accordance
with the Copyrights, Designs and Patents Act 1988.

ISBN 978 1 4456 7484 1 (print)
ISBN 978 1 4456 7485 8 (ebook)

British Library Cataloguing in Publication Data.
A catalogue record for this book is available
from the British Library.

Origination by Amberley Publishing.
Printed in the UK.

# CONTENTS

# ACKNOWLEDGEMENTS

For valuable assistance, information, access to illustrations and other much-appreciated help and support (and tea) along the way, I wholeheartedly thank the following:

Her Majesty Queen Elizabeth II and the Keepers of the Royal Collection
Robert Baker from Blind Veteran's UK
Pamela Broughton and the Owl's Trust
James Burns and the St George's Hotel
Charles Eaves at All Our Yesterdays, Colwyn Bay
Philip Evans and Llandudno Museum
Valerie Hailwood
Adrian Hughes at the Home Front Museum
Alun Pari Huws and the Royal National Lifeboat Institution, Llandudno
Karen Jones at Cameo Brides
Les Jones, Royal National Lifeboat Institution, Llandudno
Nick Jowett and the Great Orme Bronze Age Mines
Lyn Leech and the Imperial Hotel
Claire McElroy and Clare's Department Store
Jenni Morgan and Bodafon Farm Park
Anna-Marie Munro
Sally Pidcock and the Great Orme Visitor Centre
David Williams of the Ambassador Hotel
The National Portrait Gallery, London
Stamps and postmarks reproduced with kind permission of Royal Mail Group Limited
© Royal Mail Group Limited

Others also deserve a thank you; they know who they are.

# INTRODUCTION

A common perception of Llandudno might be that it was born fully formed as a flourishing resort sometime around 1850. A better description suggests that the area has a history stretching back thousands of years and a great deal of work and planning has been undertaken over many decades to shape north Wales' premier resort. What has remained constant since 1850 has been Llandudno's perspective: it has moved with the times but has not lost its identity. The work that has gone into creating the town we see and admire today is the focus of this book.

History does not unfold in discrete and convenient periods (unfortunately for authors). Dates in a chapter's title are a rough guide only to what lies within. In addition, the tourist industry is a kaleidoscope of separate industries that do not all start and stop at the same time, nor run at the same speed. Individual features are generally described in the chapter dealing with the period of their beginning; for example Punch and Judy began entertaining audiences in 1860 so is described in that chapter, even though it continues amusing old and young alike today.

Llandudno's history is so rich that not all aspects of it can be portrayed in detail. Here we aim to illuminate themes which collectively define the town as different from any other place. On occasion a topic is described as a whole; at other times the focus is on one feature or individual so as to tell the story of many. The narrative commences on the Great Orme, and by 1850 the centre has moved off the headland and onto the plain. It is with these areas that we mainly concentrate – this is not to diminish in any way Craig-y-Don or West Shore.

It all began in the Ice Age.

# AT THE CENTRE OF THE WORLD:
# PREHISTORY–600 BC

Most of the open land of Wales did not exist 15,000 years ago; vast sheets of impenetrable ice lay deep upon its surface. Then, as had happened many times before, the ice began to retreat northwards leaving in its wake a wilderness ready for colonisation. Our ancestors followed the herds as they moved into this new land, hunting, gathering, and scavenging as we went, building temporary shelters along the way. Caves, of which the Ormes' have many, held an obvious attraction – some were for living in, others were employed for ritualistic purposes.

A remarkable discovery of artefacts from this period was made from 1879 onwards in Kendrick's Cave on the side of the Great Orme: perforated and decorated teeth of deer and wild cattle, polished stone axes and knives. The most spectacular find was an engraved fragment of horse jaw alongside the remains of four human skeletons. The jawbone has been carbon-14 dated to around 12,000 years ago. This collection of artefacts suggests the cave was used as a sacred space. In the intricate manufacture of the decorated horse jaw are we seeing a glimpse of work devoted to other than the daily grind of simply trying to stay alive?

The working life of settled folk in Llandudno can be traced back to the earliest evidence remaining in the landscape, and that dates from around 3500 BC to 2000 BC. Though hunting and gathering continued, farming and stock rearing was a new way of life. Caves remained an important part of the Neolithic period but agriculture carries with it an obligation to settle and live close to the fields and, if no natural shelters exist, to build houses.

Where there might be conflict over landownership, as farming on settled land implies, there is usually some sign in the landscape that certain areas are already in someone's possession. Monumental architecture, especially that which symbolises ancestral ownership, is one way of achieving this – and the amount of work involved in quarrying large blocks of stone, transporting them to the selected site, then erecting it all using Stone Age tools, tells of the deep meaning of this activity. Lletty'r Filiast and its associated tumulus at the end of the aptly named Cromlech Road is a quite small example of a portal dolmen; but small or not it represents many months of toil for its completion.

Sometimes in archaeology an unexpected find grabs the headlines. One was that of a well-preserved female skeleton nicknamed 'Blodwen'. She was discovered deep in a fissure on the Little Orme in 1891 during quarrying operations. Blodwen was a native of Llandudno in the early part of the Neolithic, when farming was in its infancy. She was around sixty years of age when she died. Approximately 5 feet tall and powerfully built, she was accustomed to carrying

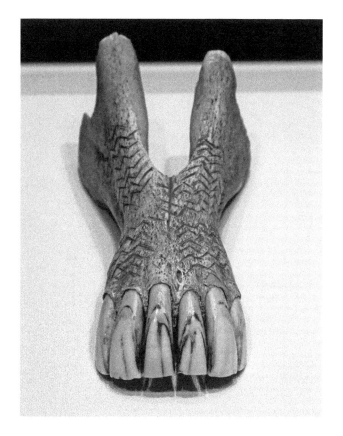

*Right:* A replica of the decorated horse jaw from Kendrick's Cave. (Courtesy of Llandudno Museum)

*Below:* Lletty'r Filiast.

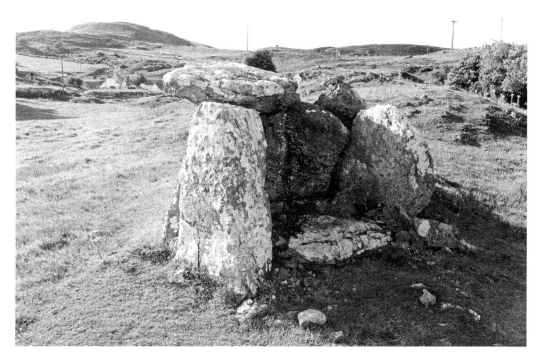

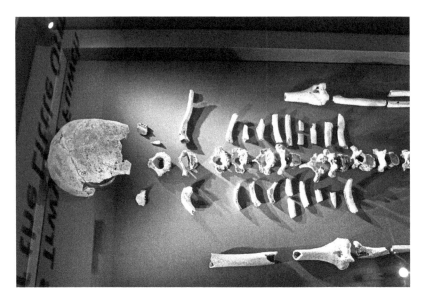

Blodwen, a hard-working resident of the area we now call Llandudno. (Courtesy of Llandudno Museum)

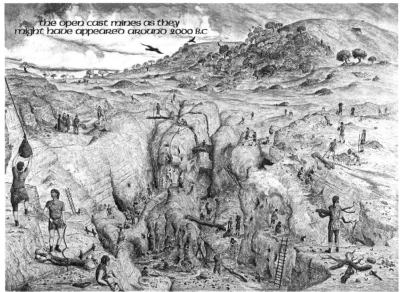

*the open cast mines as they might have appeared around 2000 B.C*

The opencast mine as it might have appeared around 2000 BC. (Courtesy of Great Orme Mines)

heavy loads, both in her arms and on her head. However this strenuous lifestyle took its toll on her for she had severe arthritis in her neck, spine and knees. Pig bones dating to the same period were found close by to where Blodwen was discovered, a sign that she came from a settled farming community. This was confirmed after tests on her bones indicated that she ate more cultivated crops and meat than wild plants or – surprisingly – fish. Attaining the age of sixty was unusual for someone in the Neolithic and it is likely that she had a high social standing within the community. As an elder she may have advised her group; perhaps her major role may have been to settle squabbles and ensure social cohesion.

Some 1,500 years or so after Blodwen's people began to farm around these parts the Great Orme was emerging as a major industrial site. In north Wales the Bronze Age dates from around 2200 BC to 800 BC. Within groups a stronger division between the haves and have-nots

was emerging and with this a necessity to possess symbols of social status – owning copper and bronze artefacts was a sign of ones higher rank. Copper on its own is a soft metal and of little value for making tools and weapons. Bronze is an alloy of roughly 90 per cent copper and 10 per cent tin and is more durable, allowing for the manufacture of harder-wearing implements. However, ores of these metals are rarely found together. Reciprocal gift exchanges and strong trade links stretched over great distances, firstly between chieftains for higher-status symbols, then for importing the required ores for the manufacture of bronze objects, which, in turn, were distributed back along the trade routes. By around 2000 BC a large opencast mine was being excavated for malachite, the copper ore which the Great Orme held in abundance.

The work involved in this enterprise employed many different skills: foresters managed woodland; carpenters made items such as ladders; fire-setters heated the rock, which fractured when it cooled; specialists gathered large, hard stones from the beach for breaking open the limestone; hauliers took the ore to the smelting site; smelters roasted the ore to separate the copper from the rock, and boat-builders constructed ocean-going vessels to transport large and heavy loads over great distances. Middle-men, traders and sailors brought tin to the site and exported the finished product. Added to this, all the essential non-mining activities had to be undertaken, such as farming, housebuilding, pottery making, child-rearing and food preparation. A major enterprise indeed, and one which had to be planned and co-ordinated effectively, probably overseen by a chief wearing bronze insignia of rank.

After a couple of hundred years the surface deposits were depleted and the veins of copper ore had to be followed underground. Eventually the miners reached depths of over 70 metres below the surface. Around 35,000 bone tools used in the mines have been analysed – around half were from cows, the others from sheep, goats and pigs.

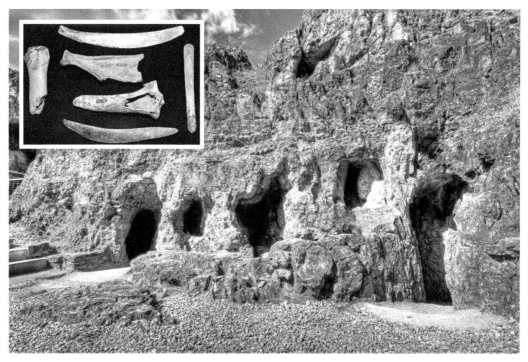

Ancient entrances to the mines, many metres below the original land surface. *Inset*: Bone picks and shovels. (Courtesy of Great Orme Mines)

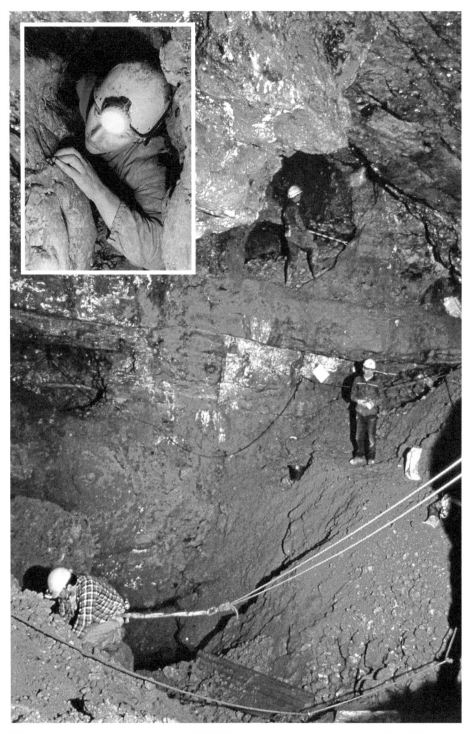

The Great Cavern, mined around 1500 BC, being excavated and surveyed in 1990. *Inset*: The smallest tunnel is just 20 cm across and is impassable to any but a small child. (Courtesy of Great Orme Mines)

At present over 5 miles of labyrinthine tunnels dating between 1860 BC and 600 BC have been surveyed by modern-day cavers, and many more miles may await discovery – a staggering extent of mining activity. Some of the tunnels were so small that only a child could have squeezed through to follow the vein of ore. In other areas the veins converged and mining produced large caverns; though the extraction of ore in these was easier, it probably took many generations of miners to do so. Life within the mines was hard and dangerous and would have been pursued only for a resource of great value. The allocation and division of labour and eventual distribution of the wealth generated by these miners is unknown.

There have been a number of estimates of the amount of copper produced by the Great Orme mine in the Bronze Age, with an upper estimate of 1,769 tonnes – enough to produce around four million axes. As further tunnels are opened this figure will increase. The mines were one of the largest industrial sites in the ancient world and had an international clientele. The importance of the site for our understanding of this era is immeasurable. However, and rather remarkably given the extent of the enterprise, no evidence has so far been found for where the miners and their families lived. Perhaps the discovery of the location of their settlements is another surprise the Great Orme holds in store for us.

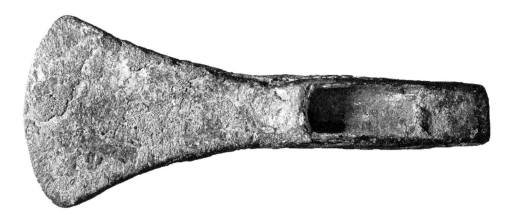

Palstave axe manufactured between 1500 BC and 1400 BC, found on Llandudno beach. (Courtesy of Great Orme Mines)

# A PLACE ON THE PERIPHERY: 600 BC–AD 1750

ronze was good, but iron was better, insofar as it produced stronger tools and weapons. Ironworking spread from the Continent – whether as an idea or through migration or invasion is open to debate. Unfortunately for our understanding of Llandudno from the Iron Age until the thirteenth century there is only circumstantial evidence, folklore and speculation. Little remains from which to draw firm conclusions about how these people worked or what they worked at doing, other than that they were agriculturalists.

There are some scattered vestiges of a small number of houses from the Iron Age on the Great Orme, but these are eclipsed by Pen Dinas, a settlement jutting out on a spur on the north-eastern flank of the headland. To the north and east cliffs and crags form a natural defence; a rampart (now much degraded) offered security on the other sides. Inside this perimeter traces of over fifty huts have been discovered, quite a large settlement in such an enclosed space. The visible remains of six circular buildings date to a later period of the site's development. But there are unresolved issues concerning its role. Were its original builders descendants of Bronze Age miners, adapting to the new world order? Was it a fort occupied constantly in these increasingly warlike times? Was it a refuge in times of attack, or was it used as shelter for villagers from further inland when summer pasture brought them here? Or, indeed, did its use change over time as history ebbed and flowed around its people?

Of the Romans who were in north Wales from AD 78 to the early fifth century there is even less evidence. A number of coin hoards found in the area suggests they were here; however, these may have been deposited by native people in times of trouble as from around 100 AD onwards Roman coinage was used by everyone in the Roman Empire. It is said that St Tudno's church had a sixth-century foundation, but no evidence for this has been revealed. By the eighth century and onwards into the age of the Welsh princes there is a similar lack of hard evidence, though further down the Conwy valley at Deganwy a princely court was a major centre of administration. Whatever political and religious situations spanned these centuries, Llandudno appears to have been rather off the beaten track, where rhythms of farming and associated trades, the sea and local affairs were the centre of work and of life.

It is perhaps difficult for us today to imagine the Great Orme quilted with fields of crops and grazing cattle and other farm animals, but in centuries past this would have been the panorama. Although not easily dated, there are clear signs in the landscape for ploughing in the medieval period. These can be observed in a number of areas of the Orme; the easiest to see are the crop marks running towards the new cemetery of St Tudno's Church from the

The remains of a circular building in Pen Dinas.

The natural defences of Pen Dinas, from the beach.

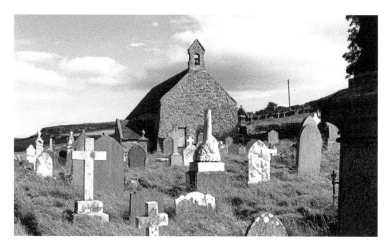

St Tudno's Church.

A landscape of early ploughing.

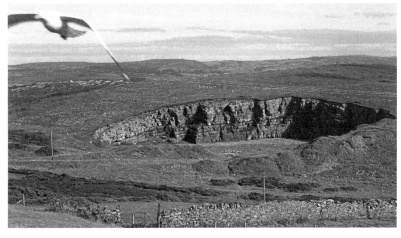

Bishop's Quarry, with inquisitive seagull.

summit. It is likely they were made by teams of oxen ploughing the same course year after year, first going one way, then turning around and furrowing the next strip. In doing so they made an inverted V, which, on ground which has not been disturbed, is still evident.

The Black Death in the fourteenth century devastated the population, leaving a much-reduced workforce to farm the land; crop-bearing fields were turned over to cattle grazing or abandoned altogether. Changes in landownership and tenancy arrangements may have also led to adjustments in agricultural practice. One such change of ownership followed Edward I's victory over Llywelyn ap Gruffudd and the building of Conwy Castle. Bishop Anian of Bangor sided with Edward and in 1284 baptised his son, later Edward II, as 'Prince of Wales'. For this support Edward granted him Gogarth (the Welsh name for the Great Orme), on which he built a palace – essentially a Great Hall with lesser rooms – with material taken from the Bishop's Quarry. The palace was ransacked during Owain Glyndwr's revolt of 1402. History suggests that matters quietened down after the early 1400s and the toil of farming, seafaring, and all the daily and seasonal life of a peasant resumed. However, the victory of the English under Edward was to bring significant changes to the governance of society and, decisively for the future of Llandudno, how certain loyalties to the English court and way of life could command great reward.

# TOWARDS A NEW BEGINNING: 1750–1850

By the eighteenth century the aristocracy had become great landowners and many had made vast fortunes. The old ways were still very much in evidence, but in certain parts of the country radical innovations were gathering pace. The Industrial Revolution brought with it unintended consequences even to places on the periphery.

## LORD MOSTYN

Edward Mostyn Lloyd (1795–1884) was the first son of Sir Edward Pryce Lloyd. He left Oxford University without taking a degree before becoming a magistrate, though by then he

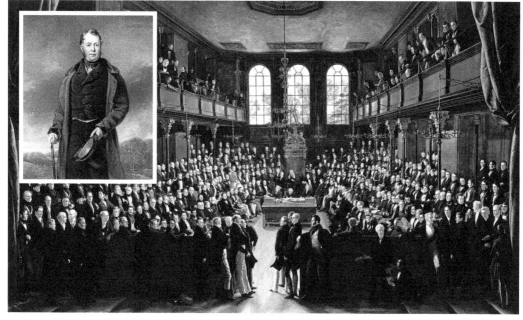

Edward Mostyn Lloyd-Mostyn in his place of work, the House of Commons, 1833. (© National Portrait Gallery, London)

had discovered a love of all matters turf-related. By 1831 he was MP for Flintshire, drawing on the emotive appeal of the name of Mostyn, which his maternal uncle Sir Thomas Mostyn had directed him to take. Sir Thomas died in 1831 and his estate passed to his brother-in-law, Sir Edward Pryce Lloyd. As Sir Edward was already sixty the effective control of these estates was taken over by his son. However, difficulties arose through Sir Thomas's various debts and bequests. The now Edward Mostyn Lloyd-Mostyn lost his parliamentary seat in 1837 and by 1843 faced bankruptcy proceedings due to his mounting debts. He succeeded his father as 2nd Baron Mostyn in 1854.

# FARMING AND THE SEA

At the other end of the social spectrum, life in 1750s Llandudno continued as it had for centuries. Agriculture and associated activities formed the core of village life and peasant farmers worked plots of common land on the low-lying area, the Morfa, between the Great and Little Ormes. A visitor in 1833 wrote that as well as sheep walks on fine turf the parish comprises 'a considerable portion of arable and pasture land, some of which is well adapted to the growth of wheat'. The sheep walks were on the Ormes; being craggy headlands they were also home for many different types of birdlife. Egg collecting was a seasonal occupation that had been carried on for centuries – the eggs of the razorbill were esteemed a particular delicacy. Rabbits trapped down on the sand dunes and harvesting the riches of the sea, whether as fishermen or as beachcombers, were further sources of food and income.

The sea had been a major highway along the north Wales coast for millennia. With the road network around Llandudno in the eighteenth century often made up of muddy paths, the sea provided the gateway for incoming goods and outgoing produce or raw materials – copper ore and the gains from quarrying on the Great Orme would be important commodities to be transported by sea in the nineteenth century. Today the train from Llandudno Junction crosses a number of ancient tracks leading straight west, from the site of a farm to the Conwy estuary. In pre-railway days the sea was also a main route for traffic from Liverpool to Menai Bridge –

Sheep on the fine turf of the Great Orme.

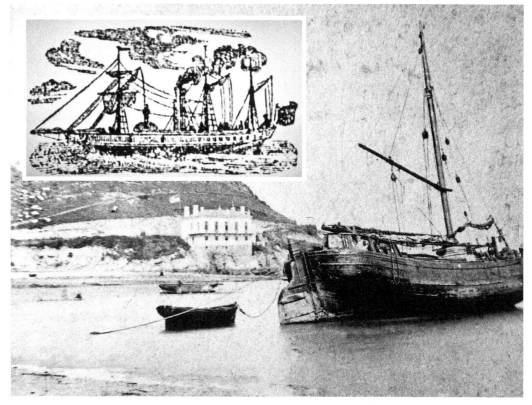

Merchant vessel beached on North Shore, awaiting cargo and high tide, *c*.1870. *Inset: Erin Go Bragh* from an 1843 advertisement.

the first steamer service began operating in 1822. A newspaper advertisement for this journey on the *Erin Go Bragh* in 1843 states that 'passengers for Conwy and neighbourhood received and landed at Llandudno Bay (weather permitting)' and that tickets could be bought from Mr Owen, at the King's Head. As Llandudno had no berthing facilities at this time small boats would row out to pick up passengers.

Maritime traffic brought with it unfortunate but inevitable shipwrecks, of which many are known around the Ormes; for example, the schooner *Rising States* was lost in 1810, though its cargo of wood was salvaged and auctioned in town. However, not all shipments were recovered when boats were lost, as cargo that washed ashore was quickly seized upon. Llandudno folk were praised for saving the lives of shipwrecked mariners on a number of occasions, but a ship's cargo was fair game. This was not always without severe consequences. In 1824 after *The Hornby* was lost off Great Orme's head with a cargo of cloth looters retrieved as much as they could – a certain W. Davies apparently 'plundering, rather upon an extended scale'. He and ten others were imprisoned.

With the increase in traffic out of Liverpool to worldwide destinations came the need for greater measures of safety and communication. To this end eleven optical semaphore stations were built at strategic points from Liverpool to Holyhead, via which a semaphore message could be sent between the two termini in under a minute (visibility permitting). The summit of the Great Orme was an obvious choice for a station, which was completed in 1827. It closed in 1861, its function replaced by a direct telegraph service.

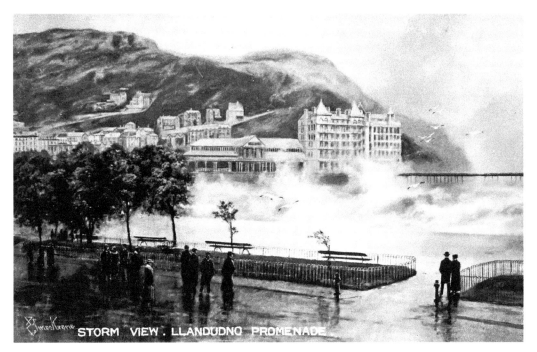

STORM VIEW . LLANDUDNO PROMENADE

A north-easterly gale and a rising tide were always a threat to shipping.

# THE COPPER MINES REOPEN

For many during the first half of the nineteenth century the occupations of fishermen, peasant farmers, seafarers, bird-nesters and occasional cargo-looters were secondary to that of copper miner. As mining techniques developed and the need for copper grew, it was considered plausible to extract ore commercially from the Great Orme. Small-scale mining began in the late seventeenth century, however, little copper was produced as flooding could not be controlled. In 1804 a report noted that there 'was, formerly, a noble copper mine at Llandudno which now lies under water, but it might, without much difficulty, be recovered by proper engines'. The 'proper engines' began to be installed after 1810 but as the mines grew flooding remained an issue. Two mines were in operation at this time – the Old Mine and the New Mine – and after 1834 they cooperated in constructing an adit from Penmorfa on the West Shore to break into and drain the flooded workings around 140 metres below the surface. This took twelve miners working shifts day and night until 1842 to drive the adit some 882 metres into the hillside. Steam engine-driven pumps and drainage tunnels facilitated the miners descending to a depth of 215 metres below the surface, some 70 metres below sea level. A third mine, Tŷ Gwyn, opened near to where the Grand Hotel now stands after 1835 when a chance find of copper ore was discovered after a cow dislodged the turf.

The miners were not organised as employees but rather in semi-autonomous gangs of six to eight men working under a leader who negotiated where in the mine they would work and at what rate of pay, though the cost of equipment used, such as gunpowder and candles, was deducted from this, leaving probably not a great deal to cover their rents. Unfortunately, even these pickings were not for everyone: in April 1818 'two cart loads of all kinds of provisions, for the poor of Llandudno, were distributed amongst distressed objects'. As the vestry minutes from the 1820s confirm, charitable donations were a lifesaver for many.

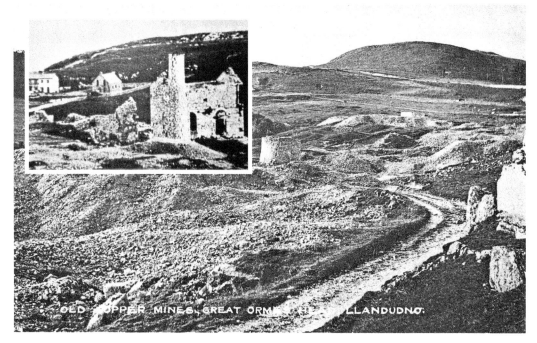

The Old Mine around 1900, showing Vivian's Shaft and extensive spoil heaps. *Inset*: Ruins of the Old Mine. (Courtesy of Great Orme Mines)

Preserved nineteenth-century clog and hobnail boot prints from deep in the mines. (Courtesy of Great Orme Mines)

Former miners' cottages on the Old Road.

An excavated bell pit with its associated spoil heap.

The years of plenty for the mines were between 1830 and 1850. After this period flooding, foreign competition, strikes and more competitive wages being offered elsewhere were some of the factors which conspired to bring about their closure.

Other evidence for mining on the Great Orme, probably from the nineteenth century, is visible in the landscape at Bryniau Poethion near the Bronze Age mines. Bell pits were dug by hand and when sufficiently deep were entered by crude ladders; after the ore had been extracted they were abandoned and the miner would move on.

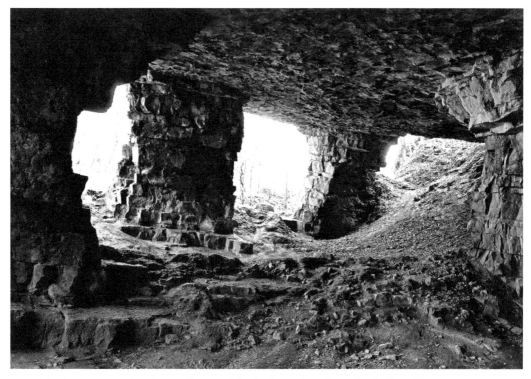

Elephants Cave, showing evidence of the 'pillar and stall' method of working.

St George's Church, built in 1840 and privately owned from 2002.

Many small and some larger quarries can also be discovered, evidence for an extractive industry stretching back to Neolithic times. This stone makes good building material and was particularly exploited in the nineteenth century.

By the 1840s, when the mines were at their most productive, the new church of St George had been built on Church Walks. A little further along, St George's National School had opened for scholars and in line with the rest of the country the population of the village was increasing: in 1801 it was home to just over 300 souls, by 1851 it had risen to 1,131. Llandudno was slowly evolving, largely from within, though by this time outside influences were taking an increasing interest in the area.

# A SHREWD SCHEME

Since the eighteenth century the landowning aristocracy across Britain had sequestered common lands into their private ownership. Through the Enclosure process the Mostyns laid claim in 1794 to a parcel of land on which Rhyl was built. In 1843 Edward Lloyd-Mostyn was declared bankrupt and Llandudno's Enclosure Bill was published. Parliament passed the Bill without question and he gained as freeholder 832 of the 955 acres of common land covered by the Act. The idea of developing the area as a port was considered, but the building of a new seaside resort became the preferred option and in 1849 the first leases of 176 lots now owned by Edward Lloyd-Mostyn were auctioned.

The clearance of the Morfa followed soon after; the tenants had not the resources to resist nor were they represented in Parliament. However, it has been pointed out that they were eventually rehoused in Madoc Street, which offered a better quality of housing than on others – suggesting that the new freeholder had adopted a carrot and stick approach to their removal.

Edward Lloyd-Mostyn chaired a parish meeting in 1853 at which it was agreed to apply for an Improvement Act to install a Board of Improvement Commissioners to oversee the new development. A year later the newly built St George's Hotel graced the seafront. The old close-knit community had been extinguished virtually overnight and a quite different Llandudno created in its place.

# THE BIRTH OF LLANDUDNO AS A RESORT: 1850-1900

'There are few places, even in populous and wealthy England, which have so suddenly sprung into notoriety and importance as the still rising town of Llandudno.'

*North Wales Chronicle*, June 1855.

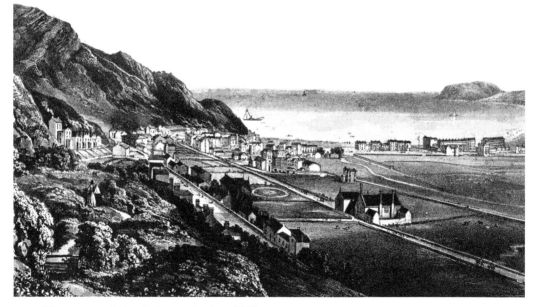

The extent of Llandudno in the late 1850s.

## THE FIRST STEPS

Notice was given in November 1853 that under the proposed Act of Parliament the Board of Improvement Commissioners would be 'empowered to act as the surveyors of all highways' and be responsible for 'Paving, Lighting. Watching, Supplying with Water, Cleansing. Regulating', and 'for making a Cemetery, and for establishing and regulating a Market and Market Place, and for other Purposes' to 'improve and regulate the Town of Llandudno'.

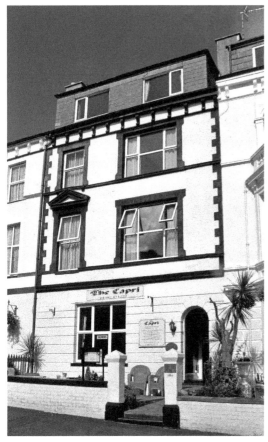

*Left*: The offices of the Board of Improvement Commissioners is now The Capri guest house.

*Below*: Llandudno Town Hall.

The Royal Hotel.

The commissioners sat from 1854 at No. 70 Church Walks, now occupied by The Capri guest house.

There were a number of teething problems. Ten years after the first meeting concerns were being voiced about many issues, such as pigs in the town, sewers being inadequately flushed and that roads were badly constructed. It took a further ten years before it became fashionable to plant trees along the streets. However, there were still improvements to be made. By 1891 the commissioners were proposing experimental metalling with Penmaenmawr stone on some 300 yards of Lloyd Street so as to combat the dust nuisance. In 1895 the work of the commissioners was taken over by Llandudno Urban District Council. The 3rd Baron Mostyn, Chairman of the District Council in 1902–03, donated the site on Lloyd Street for the new town hall, which was completed in 1902.

The first hotel to be built in Llandudno started life as the Mostyn Arms, later renamed the Royal Hotel, on Church Walks. Its owner, Robert McLellan, was elected a commissioner in July 1855; his first committee membership appears to have been to deal with complaints about the town's water supply and to examine ways of providing one which was constant and free.

An inquest in October 1857 unwittingly gives some interesting details about the area at this time. The court considered the death of a man caused by a coach overturning on the road from Conwy to Llandudno, a road which was in such a poor condition that only 'the very best description of omnibuses' – carriages drawn by four horses – 'could run over it with safety'. The proprietor of this omnibus was Mrs Lydia McLellan of the Mostyn Arms. The coroner absolved her of responsibility as in the previous year she had sent the coach to Birmingham for it to be repaired and renovated.

The first hotel to be completed on a seafront plot was the St George's, owned by Isaiah Davies. Thursday 24 August 1854 witnessed its grand house-warming dinner. Isaiah Davies was something of a precocious entrepreneur. He was born in 1830, son of Thomas Davies, a farmer on the Little Orme. Aged nineteen he married twenty-four-year-old Anne Owen, daughter of the landlord of the King's Head; by 1851 the couple had inherited the inn. Just three years later St George's Hotel opened for business. Over the following years he ran this venture successfully and the hotel was extended along The Parade. However, in the 1870s certain difficulties can be presumed as in 1876 he had been summoned to appear before the commissioners regarding non-payment of rate arrears. All seems to have worked out well for him for in 1878 the stabling block was rebuilt as a grand new wing. Isaiah died in 1881

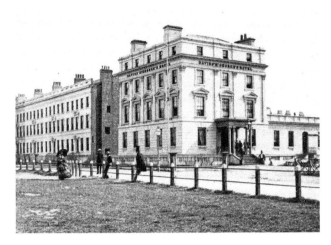

St George's Hotel, summer 1859, by Francis Bedford. The single-storey building to the right is the hotel's stabling block.

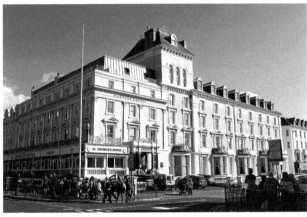

St George's Hotel. The water tower that powered the hotel's first lift was added by 1896.

and Anne became the proprietor until her death in 1896, whereupon their son Thomas Pugh Davies took over the business. It remained a family concern until 1977.

The foyer of the hotel retains original brass bell-knobs labelled 'Chambermaid', 'Boots' and 'Ostler' by which certain staff could be called. The census, taken every ten years, gives other details of the hotel's staff over the decades. In 1861, seven years after the hotel opened, the census lists Isaiah and Anne and their five children with seven female 'general servants' and one chap who was a waiter. Twenty years later the hotel had been extended and the number of live-in staff had doubled: the workforce was predominately female, three men were employed as 'billiard marker', 'upholsterer'' and 'boots' while the twelve women staff comprised a 'housekeeper', two 'cooks', two 'laundresses', two 'parlour maids', two 'waitresses', two 'housemaids', a 'barmaid', and the only two recognisably local members of staff, Llanrhos-born cook Catherine Hughes and Llandudno-born Anne Hughes, the scullery maid. Come the turn of the century and the live-in workforce (mostly from England) had again doubled in number and now included a 'hall maid', a 'stillroom maid', a 'page', a 'vegetable cook', a 'kitchen maid', a 'head boots', an 'under boots', and a 'bus driver' (a horse and carriage driver).

In the nineteenth century live music had been presented by outside performers, but in the early decades of the twentieth many larger hotels employed in-house bands to entertain their guests. By then the hotel trade had grown and had adapted to changing fashions.

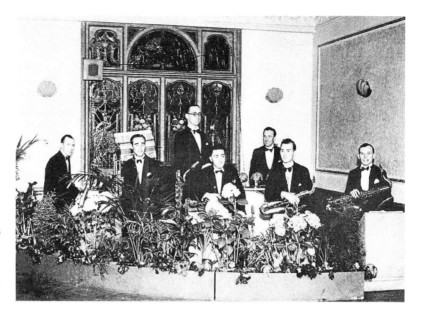

St George's ensemble, probably in the 1940s, in the Conwy Suite. (© St George's Hotel)

To state the obvious, Llandudno is a seaside resort. The attraction for this development was largely the sea itself, though perhaps not for the reasons we would recognise today. Splashing about in it began to be fashionable in the eighteenth century. At first the fun element was not the purpose for this activity; it was the professed health benefits which encouraged people to enter the (often cold and grey) sea – and to drink it.

An English visitor in the late eighteenth century had noted a local custom of nude sea-bathing. In an area on the periphery, where coal for heating baths was a scarce and expensive commodity and water had to be drawn from a communal well, where men worked in dirty and rough environments, it is perhaps not surprising the sea was deemed to be a welcome and free resource. Manual workers who had little or no access to medical treatment may have noted that it acted as a mild antiseptic – this could have been part of established folk wisdom.

This traditional practice was embraced by some visitors to the town, to the outrage of onlookers. Claim and counterclaim about the value of this activity were bandied about in the 1860s. Inevitably the commissioners decided this could not continue and passed a resolution that all bathers not wearing appropriate apparel would be fined; however, reports of the practice continued to be heard.

In order to preserve a bather's dignity, Llandudno had previously implemented two approaches. The first was geographical. The western end of North Shore was set aside for pleasure boats, and much further along, in front of the Queen's Hotel, was an area for 'Ladies' Bathing'. Gentlemen had even further to walk: their bathing place started where the Imperial Hotel now stands and vanished off the bottom of the map.

Yet this was not enough. The second necessity before one entered the water was to do so in a bathing machine. Essentially these were small wooden huts on wheels which could be moved into the water, allowing folk to change out of their usual clothes and into swimwear before wading discreetly into the ocean. They began being offered for hire along the North Shore in 1855 and by 1880 at least eight individuals were hiring them out. As the twentieth century progressed so the rules of etiquette changed, and segregated bathing areas and bathing machines gradually disappeared.

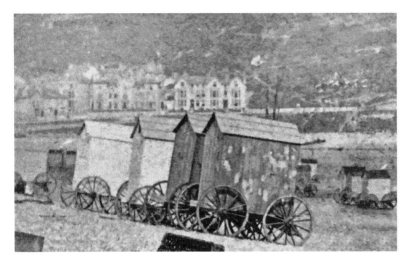

Bathing machines, summer 1859, by Francis Bedford.

2017 and not a bathing machine in sight.

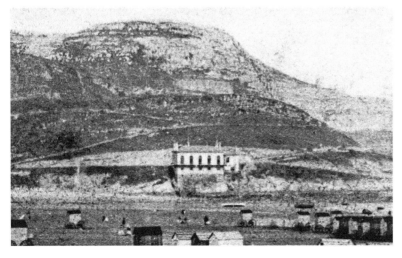

Bathhouse, with bathing machines in the ladies' section of the beach, 1859.

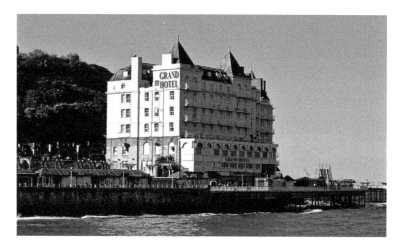

Grand Hotel and pier, 2017.

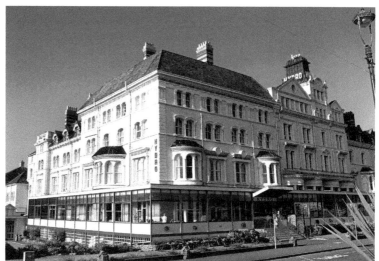

The Hydro.

Outdoor bathing was by no means the only method by which therapeutic seawater could be enjoyed. In 1855, a bathhouse with indoor swimming baths, a reading room and billiard hall was constructed below the eastern side of the Great Orme. This building predated both pier and seawall and was comprehensively extended in the 1870s to become the Baths Hotel. This in turn was significantly reconstructed in 1901 and reopened the following year as the Grand Hotel.

The fashion for 'water cures' was growing apace, and with it the purpose-built 'hydropathic establishment'. The first of these in the town was the Llandudno Hydropathic Establishment Ltd, essentially a hotel with facilities for various water cures. It was built in 1860 to a design by its first director, Dr John Edward Norton, a regular physician turned homeopath. An advertisement of 1873 declared that 'the house is thoroughly warmed and ventilated with hot air, which much enhances its value as a winter residence for invalids'. In addition, the advertisement promotes not only the hotel's ordinary homeopathic appliances but also 'four Russian vapour and two commodious and well-appointed Turkish baths' and 'the Seaweed or Ozone bath'. Exercise facilities were on offer as well, namely an 'American Lifting Machine' for 'cumulative exercise'— in other words, precursors to the steam rooms and gymnasium equipment to be found today in modern health spas.

Since the town's inception all building work has been under the supervision and guidance of Mostyn Estates, adhering to strict regulations. These include that no building should be higher than the width of the street and there were to be no court houses. The overall effect is for a coherent townscape to present itself. As the town grew new generations of architects added their distinct mark and something of a change in emphasis can be noted after 1900, though the original principles continued to be followed. A small sample of architects' work in Llandudno is maybe better expressed in images rather than words.

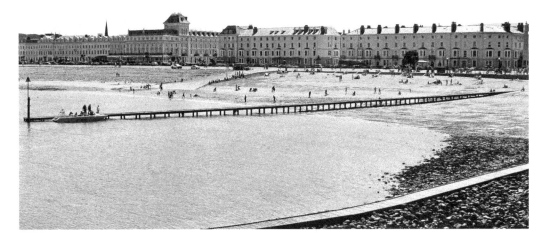

The outcome of Llandudno's planned development.

St Kilda Hotel, Gloddaeth Crescent, c. 1865, by J. A. Chatwin of Birmingham.

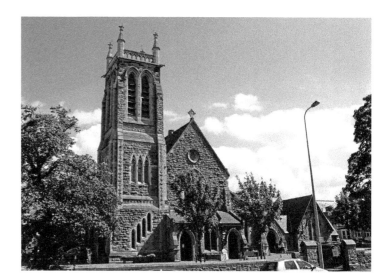

Holy Trinity Church, Trinity Square, 1865–74, by George Felton of Llandudno.

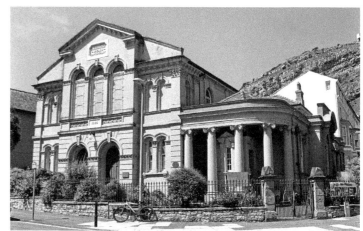

Tabernacle Baptist Chapel, Llewelyn Avenue, 1875, by Richard Owens.

Bodlondeb Castle, Church Walks, 1890s, Thomas Pugh Davies, builder.

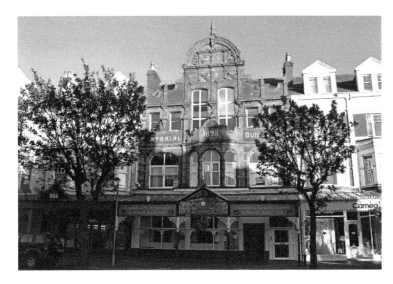

Imperial Building, Vaughan Street, 1898, by G.A. Humphreys.

# THE UNTAMED OCEAN

The sea which attracted the first tourists provided much, though it also took away. The tragedy of the *Royal Charter*, which foundered off the coast of Anglesey in October 1859 resulting in over 450 fatalities, had a profound effect locally. A month later two local men requested that the Royal National Lifeboat Institution (RNLI) consider establishing a lifeboat at Llandudno. After the required formal processes were completed the town received its first lifeboat on Monday 14 January 1861: the *Sisters' Memorial* arrived by train. The funding for the vessel – £200 – was provided by two sisters from Liverpool who, along with a third, had visited Llandudno often – the boat was named in memory of their sister. As continues today, all RNLI funding comes from voluntary donations by the public. The original boathouse was placed adjacent to the railway station, theoretically allowing for speedy access to the coast between Colwyn Bay and Penmaenmawr.

After much valuable life-saving service the *Sister's Memorial* capsized attempting to help a ship in distress 8 miles off the Great Orme's Head in February 1867. As a consequence the RNLI sent a slightly larger vessel to Llandudno, the second *Sister's Memorial*. Twenty years of exemplary service later witnessed her capsizing in terrible sea conditions. A new boat was required and George Felton, the local RNLI Honorary Secretary, with the two coxswains, R. and E. Jones, offered valuable suggestions as to the build and equipment necessary. The new vessel was *Sunlight No. 1*.

John Hughes was coxswain of *Sunlight No. 1* when a couple of chaps 'roaming about the Little Orme's Head' were surrounded by the tide. A crew of four took her out to rescue them. The report does not state what the conditions were, though they must have been unusually difficult as the matter was reported to the Royal Humane Society, who in turn forwarded to Revd J. Raymond, local Honorary Secretary of the RNLI, certificates on vellum to be handed to the rescuers: Coxswain John Hughes, Bowman John Williams, Thomas Hughes and H. Jones. John Hughes was also coxswain for the first two years of service of the next lifeboat, the *Theodore Price* (on station 1902–30). In 1903 it became the first vessel stationed at the new lifeboat house on Lloyd Street. This central position between North Shore and the Conwy estuary ensured that she could be taken with equal ease to either, depending on the location of the casualty and weather and tidal conditions.

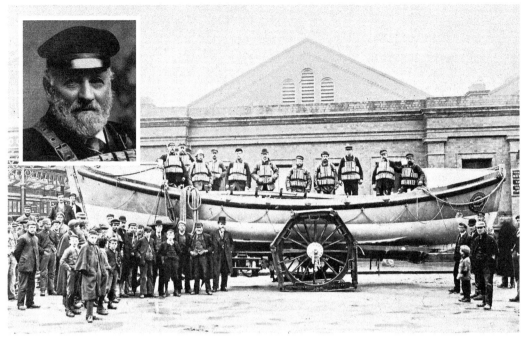

*Sunlight No. 1* (on station 1887–1902) outside the railway station. (Courtesy of RNLI) *Inset*: John Hughes, coxswain 1890–1904. (Courtesy of Les Jones)

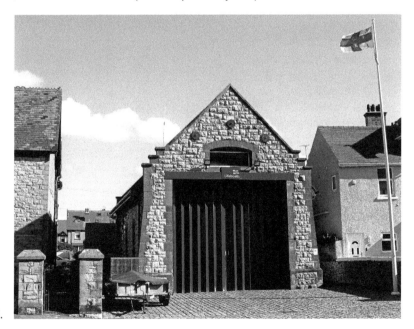

The station on Lloyd Street, opened in 1903.

The weather was foul on 27 March 1919. A fierce gale blew in from the north-west which destroyed the sails of the schooner *Ada Mary*, soon to drift before the wind and tide towards Penrhyn Bay. The *Theodore Price* was launched at 1 p.m. – she was repeatedly swept by huge seas and completely swamped three times or more. Once they reached the schooner Coxswain

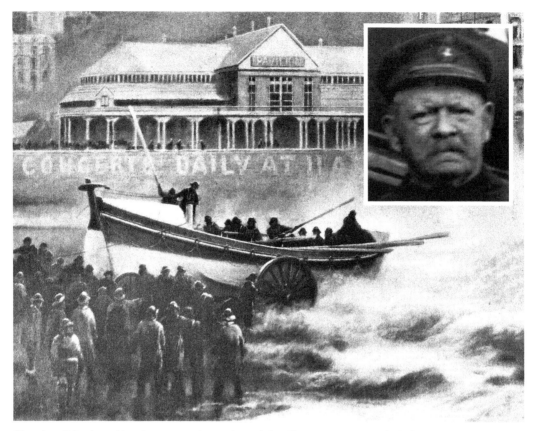

*Theodore Price* launching into a rough sea. *Inset:* John Owen, coxswain 1918–30. (Courtesy of RNLI)

Owen manoeuvred the lifeboat alongside so that the two exhausted men aboard could be rescued, but the return to Llandudno proved an impossible undertaking as the lifeboat could make no headway against the tide and raging gale and it was only after several hours that they gave up the attempt. Coxswain Owen turned the *Theodore Price* towards the south-east and beached at Colwyn Bay. The RNLI awarded him the Bronze Medal for his skilful service under the most arduous conditions.

The year 1862 witnessed a further significant development for safety at sea when Llandudno's lighthouse, high above cliffs at the most northerly point of the Great Orme, shone its light across the ocean for the first time. The building, which resembles a fortress, was built by the Mersey Docks & Harbour Board. The lamp room was unusual in that it rested on the ground at the side of the lighthouse, a position from which it could emit a beam 180 degrees across the sea and not over the land behind. The original lamp is on view in the Visitor Centre near the Summit Complex.

The old Semaphore Station had become the Telegraph Signal Station by 1861 when Job Jones and his family lived there. Ten years later he had moved into the lighthouse where he was now 'Lighthouse and Telegraph Keeper'. The staff of the lighthouse comprised a senior lighthouse keeper and one or two deputies. Usually two families shared the living accommodation – privacy was ensured as the two households were separated by a tall wooden hallway (which remains in place today).

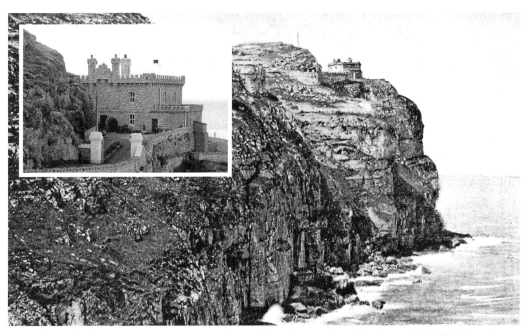

The lighthouse perched on the edge of the Great Orme's sheer cliffs, 325 feet above sea level.

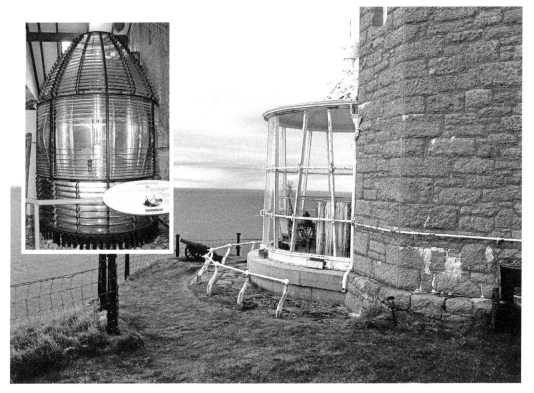

The lamp room. *Inset:* The original lamp. (Courtesy of the Great Orme Visitor Centre)

After over 120 years of guiding shipping along the coast the lighthouse closed in 1985. It has since been converted to a guest house, though it retains many of its original features. The view of the wide ocean remains as spectacular as ever.

# GETTING THERE AND THEREABOUTS

Until the early 1850s the area was a place to visit to enjoy the dramatic scenery of the Great Orme; it was a diversion off the main routes. *The Cambrian Mirror* from 1843 noted that the mines were employing several hundred men, a new church had been built and that the King's Head 'is a good inn where every accommodation may be procured'. Interestingly, some residents on the Orme appear to have been setting up a small-scale tourist infrastructure before the passing of the Enclosure Act, which set in motion the development of Llandudno. As soon as the first hotels had been built Llandudno became a destination in itself and also a base for touring north Wales. As visitors arrived in greater numbers, so the 'tourist' aspect of their nature changed Llandudno's outlook. By the mid-1850s it was possible to take 'The Most Picturesque & Expeditious and the Cheapest Tour in north Wales' from Llandudno, via Snowdonia, to Bangor in a 'well-appointed four-horse coach'.

The larger hotels kept their own stock of horses and carriages. St George's Hotel, soon after opening, advertised that a handcart would convey luggage from any part of Llandudno to the hotel in time to catch 'the omnibus'. They also offered from their own stables 'Neat Cars, Brougham, &c, for hire, and steady Drivers' for those with a spirit of adventure who wished to make their own travel or touring arrangements.

Within the town itself horse-drawn (and donkey-drawn) vehicles were a common sight well into the twentieth century: for carrying people (forerunners of today's taxis) and, as they had done for centuries, for transporting raw materials and finished products.

The woes of a tourist in 1901.

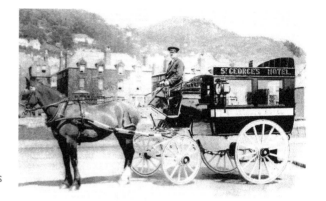

St George's well-turned-out horse-drawn carriage with driver Bill Martin in 1920. (© St George's Hotel)

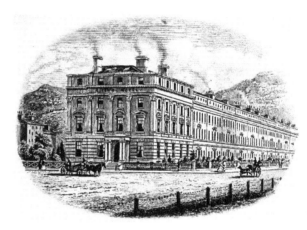

Outside the newly built Queen's Hotel, *c.*1856, when the roads were a little quieter than they would soon become.

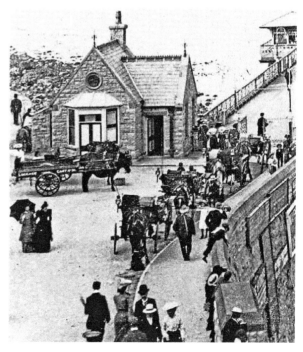

Horse-drawn carriages and a donkey and cart waiting to pick up fares at the original entrance to the pier, *c.*1900.

Unfortunately – or perhaps predictably – turf wars sometimes broke out between members of Llandudno's coaching fraternity; for instance, as regards to who could legitimately pick up passengers from where, and whether the larger companies were attempting to monopolise certain routes. A further problem was the increasing volume of traffic causing obstructions in certain areas. All this came to head in 1893, prompting the commissioner's to issue a number of byelaws regulating traffic, though this seems to have had partial success only. They were particularly concerned for the image of the town after a 'dispute' on South Parade between rival firms 'produced almost a revolt last year, and most disgraceful scenes took place' – that is, fisticuffs broke out, maybe not too unexpectedly as many of the drivers would have been young lads.

The train arrived late in Llandudno. It reached Conwy in May 1848 but took a further ten years to find its way to the growing seaside resort. The station opened in 1 October 1858; the instigators of this line, the St George's Harbour and Railway Co., were soon absorbed by the London & North Western Railway. At first the train to Llandudno ran directly to Conwy, as the junction station (Llandudno Junction) had not been completed. But all was not well when it was opened. In August 1859 a rail passenger complained that the trains from Chester going to Holyhead were frequently half an hour or more late, during which time 'the unfortunate passengers to and from Llandudno are exposed to the pitiless storm and pelting rain, not a single cover of any description being provided for them'.

The arrival of the railway did not lessen the attraction of horse-drawn travel; indeed, it was preferred by some for journeying to Conwy and elsewhere as the drive was 'more picturesque' and considered to be more convenient. It was still the only means of transport between places not served by the railway and for visiting areas somewhat off the beaten track.

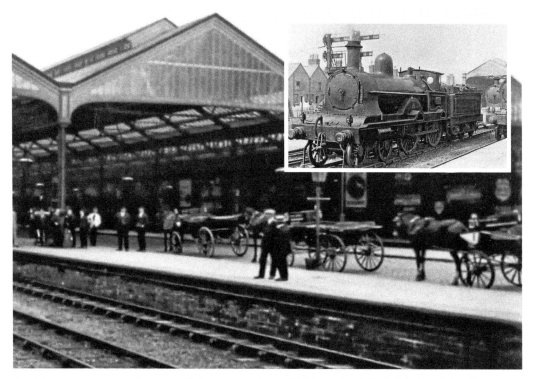

Awaiting passengers and goods off the next train, *c.*1900. *Inset:* LNWR 4-4-0 *Alfred the Great* class locomotive outside Llandudno station, *c.*1905.

The refurbished entrance to Llandudno station.

As more visitors arrived in Llandudno decade upon decade so the station became overwhelmed and eventually rebuilt in 1892. The rail infrastructure was also under strain and new lines and yards had to be built outside the station to cater for the increasing number of locomotives and carriages. From these halcyon days for rail, the rise and dominance of the motorcar and the swingeing effects of Lord Beeching's report of the early 1960s brought about the closure of many rail services across the country. The lines and marshalling yards of Llandudno station were abandoned and dismantled and the building itself amended and tinkered with until 2014 when Network Rail invested £5.2 million updating it.

# ALL THE FUN OF THE SEASIDE

The Great Orme's natural beauty was appreciated by walking beyond the old town and up the Old Road, to take tea at the Telegraph Station or on to St Tudno's Church, or maybe picnic and simply enjoy the views. Soon someone had the bright idea that a path around the Orme would make an additional attraction. It befell a trustee of Mostyn Estates, Reginald Cust, to survey and engineer the route. The construction of Cust's Path (as it became known) took from 1856 to 1858 and swept around some precarious rock faces. Although in its time a work of some value, it quickly attracted criticism. British prime minister W. E. Gladstone had to be blindfolded at more frightening stretches before he would go any further.

By 1865 two companies were vying for a contract to construct an 'unquestionably much desired carriage drive round the celebrated Cliff Walk'. Local government being what it is, in November 1870 a committee met in the Boardrooms on Church Walks to further discuss 'the proposed drive around Great Orme's Head'. Included on this committee was Job Jones from the lighthouse. The contract was eventually given for a cost in 'the neighbourhood of £10,000' (actual cost, £14,000). Finally, in September 1875, several dignitaries and 'an immense concourse of spectators assembled in the Happy Valley' (though the weather was abrasive) to witness the cutting of the first sod by Mr Joseph Evans, chairman of the Drive Company. It was anticipated that the route would be completed by June 1877. It was not, but in that month the workmen were given a dinner at the Royal Hotel in acknowledgement of 'the good and substantial work they had made'. A year later the 5-mile-long drive and two toll houses were finished, the outcome of which was a masterful display of Victorian engineering.

Immediately, an argument erupted: as it was in town between rival carriage companies, so here. Owners of Hackney carriages were monopolising the market and those who drove other vehicles, such as Evan Jones, were not impressed and advertised trips around the Orme

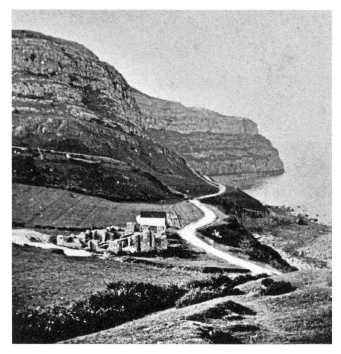

The newly constructed path at the bottom of what would become Happy Valley.

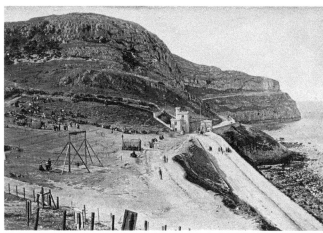

The newly built Happy Valley Toll House and Marine Drive, *c.*1880. The large children's swing, lower left, was so conspicuous it appeared on contemporary maps.

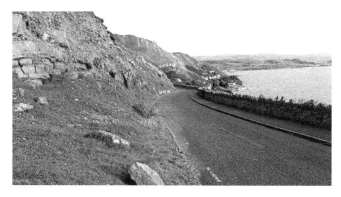

Marine Drive descending towards West Shore.

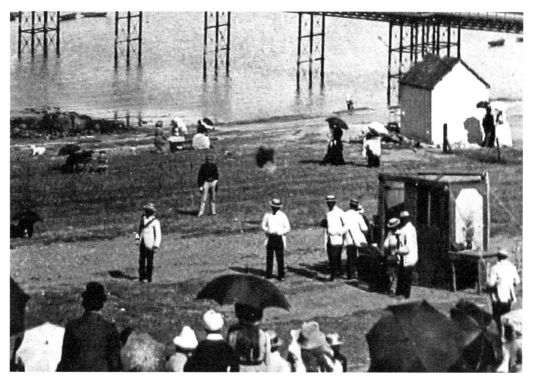

Minstrels performing al fresco, *c*.1890.

Built to celebrate Queen Victoria's Diamond Jubilee, unveiled in 1890.

in defiance. Eventually matters settled down and Marine Drive became one of Llandudno's popular attractions.

Further up Happy Valley quarrying was actively pursued up to the late 1880s. After Cust's Path had been completed the area near the sea became a sheltered spot close to the town where ginger beer was sold and games could be played – there was also an archery ground. By the 1870s live music had broken out and performances were presented in front of an audience seated on nearby grassy slopes. To celebrate Queen Victoria's diamond jubilee in 1887, Lord Mostyn donated the now quarry-less valley to the town to use as a park with ponds and a garden. This was opened in 1890, the same year the bust of Queen Victoria was unveiled. Since then these gardens have matured and now produce a fine display in all seasons, helped, of course, by the gardeners who tend them.

As a contractual obligation the St George's Harbour & Railway Co. built Llandudno's first pier in 1858, though this was severely damaged in the storm of October 1859 and rebuilt. Its purpose may have been for loading boats with stone from the nearby Happy Valley quarries. However, larger boats could not dock except at high tide. As business was being lost the decision was made to build a much grander structure, work taken on by Walter McFarlane, builders from Glasgow. The pier was erected in just one year and opened in 1877. It was an immediate success: a band played at the pier head, large boats could now dock and it afforded wonderful views for those taking a stroll along Wales' longest pier. The landing stage was modified twice and in 1969 was replaced by a concrete and steel pier head. Originally access was from the road leading to Happy Valley. In 1884 the pier entrance from North Shore was opened.

The rebuilt pier as seen from Happy Valley, *c.*1865. Piles now much closer together and splayed – an altogether sturdier construction. *Inset:* The original pier, midsummer 1859, severely damaged that October. The landside piles appear to be unusually far apart.

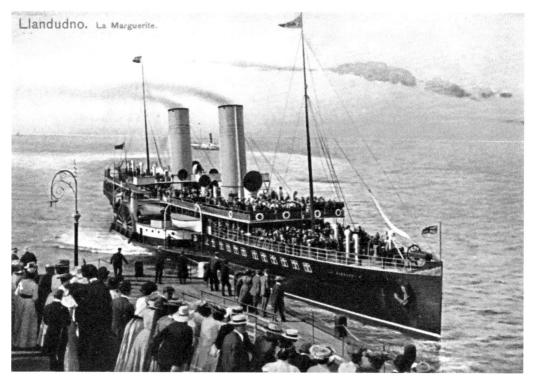

*La Marguerite* arriving at the new pier, c.1906.

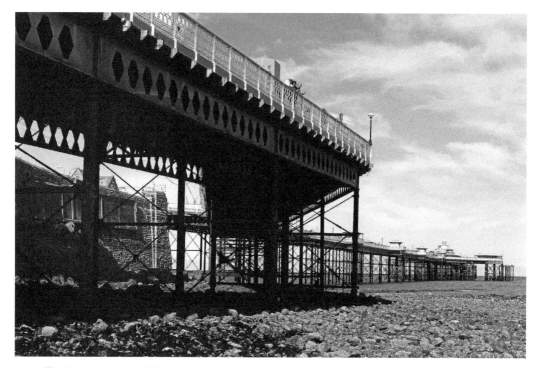

The longest pier in Wales.

With the new town came new employment opportunities. For miners and others who owned a small boat and who knew the local coast intimately, it must have been most tempting to take advantage of the prospects arising: excursions in such craft around the bay and the cliffs and caves of the Ormes began to operate soon after the first visitors arrived. For decades afterwards North Shore and the bay were awash with small- and medium-sized boats. From the beginning the boats sought their custom in front of North Parade and passengers would transfer directly onto the partially beached vessel. Eventually a small jetty was built, making the transfer easier for passengers and probably less damaging to the craft – today's jetty is the latest in this location. Being neighbours on land, boatmen usually assisted each other at the shore, but not always, as in 1879 when James Hughes became a little agitated and 'pulled the whiskers' of William Moss for refusing to help him launch his boat.

Boat trips around the bay and the Great and Little Ormes continue today, as does the chance of spotting dolphins, seals and many seabirds. The two latest innovations might have surprised the early boatmen, the first being a high-powered speedboat ride, the second a tour to the offshore wind farm.

Riding donkeys on the beach would have been an abiding memory for many visitors to Llandudno. The location for hiring such fun quickly became sited between the pleasure boat area and the ladies' bathing machine zone. The donkeys usually had their name emblazoned on their harness so they could be identified for the next trip to the beach.

By 2010 concerns from various groups were being raised nationally, in particular, of overweight adults seated on the animals, the safety of the children and, in the view of some councils, that the cavalcades trotting along Britain's beaches were a danger to sunbathers. Due to this pressure donkey rides on the foreshore seemed destined to disappear. However after the Donkey Sanctuary issued guidelines, rides along the beach on a sunny day can be enjoyed by another generation of children.

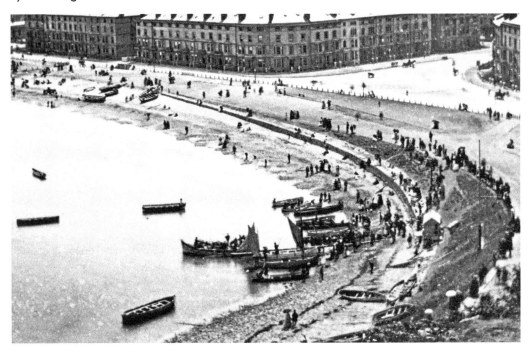

Pleasure boats plying for trade, c.1870.

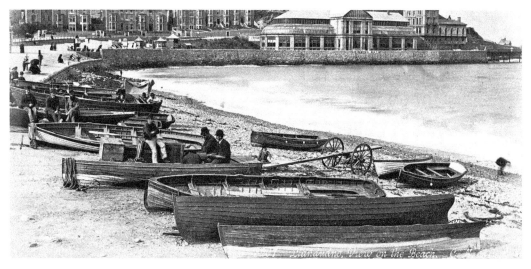

Boats and boatmen, c.1890.

Boarding *Sea-Jay* for a trip out from the shorter jetty.

On shore new entertainments were becoming established. Mr Punch began life over 400 years ago in Italy. He was operated by strings from above and played to large crowds in theatres. At some point in his history he was given a distinctive voice by the puppeteer using a swazzle (similar to a kazoo), whereas all other characters are voiced normally. By around 1800 Punch began to appear as a glove puppet from within a narrow, lightweight booth, usually with an assistant to gather a crowd and collect money. It is in this guise that Codman's Punch and Judy enthrals spectators on Llandudno's promenade across from North Parade, and has done for almost 160 years.

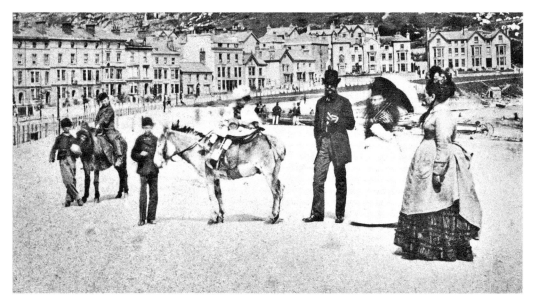

Donkeys for hire in the 1870s.

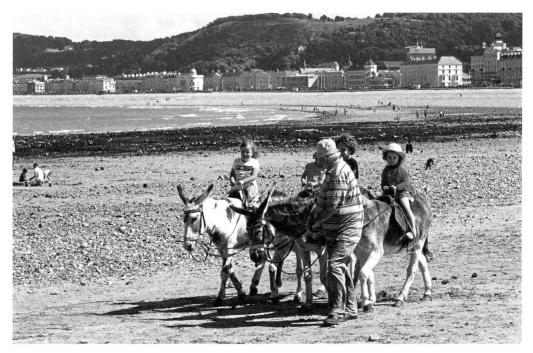

Young jockeys in 2017.

In the early nineteenth century George Codman had been variously a silk weaver, publican, musician and showman in Norwich. His son Richard became a musician, touring around country fairs with banjo and fiddle, accompanied by his dog Toby (which, of course, is the name of Punch's dog). Eventually he mastered the intricacies of Punch and Judy. It is said that he found some driftwood while walking on Llandudno's beach, from which he carved

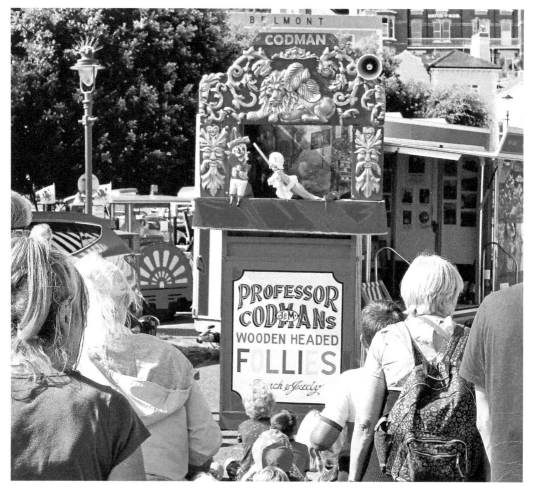

Professor Codman's Wooden Headed Follies.

his original puppets. In 1860 he began operating on the promenade, continuing to do so in the summer season for twenty years; he settled in the town in the late 1870s. His first shows earned the displeasure of Lord Mostyn, who was not impressed with this type of entertainment in his Llandudno, though the problem was quickly resolved when Richard presented his show to the Improvement Commissioners. Codman's Punch and Judy was soon playing to appreciative audiences in Llandudno and around the country (including to members of the aristocracy and Queen Victoria herself) and in Boston, USA. 'Punchinello Artist' Professor Codman's performances lasted over an hour; the modern show has been fine-tuned to thirty-five minutes of the core of the story of Mr Punch's misdeeds and eventual comeuppance and remains true to its tradition.

Towards the end of the century another attraction had appeared at this end of the promenade. In 1900 the *Harmsworth Magazine* informed its readers, 'it will be news to most people that Llandudno has the most remarkable seaside attraction in the world', Signor Gicianto Ferrari's 'wonderful bird actors'. He hailed from in Genoa, Italy and, after a short stay in Brighton, moved to Llandudno around 1880. As with other Italian migrants he made his trade that of ice-cream vendor, reputedly Llandudno's first, with a shop in the market hall.

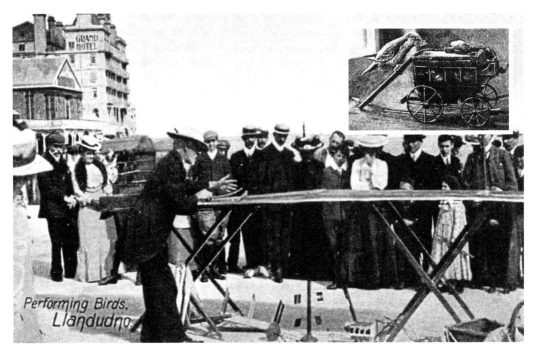

Signor Ferrari at work with his performing birds in the early 1900s. *Inset:* The porter

His claim to fame was as *The Bird Man of Llandudno*, performing most mornings during the summer season to large and appreciative audiences on the promenade close to the pier entrance.

He trained his birds – a species of parakeet – many novel tricks. In one a bird acted as a porter carrying toy suitcases to the top of a coach. In another, a bird sat nonchalantly at the end of a horn through which Signor Ferrari blew. Perhaps the most famous of the stunts was when three birds perched unconcerned at the end of a gun barrel as he let off a shot. Unfortunately the birds did not always behave themselves. As one observer noted, 'if by any chance they do not act exactly as they are told, their trainer does not let it pass, but insists on his commands being filled to the letter'. Perhaps for many of the audience the high point of the show was when they did not follow orders and flew into a nearby tree, thereby ensuring his wrath. Signor Ferrari continued performing at the spot he had made his own into his seventies. He died in 1923 and is commemorated with a plaque at the entrance to the pier where he had entranced audiences with his 'wonderful bird actors' for over two decades.

With all the exercise and fun on offer, any self-respecting seaside town has to have a continual supply of fizzy drink for sale – being on holiday can be thirsty work. Disentangling how this reached customers can sometimes be problematic, as it can be with many other categories of early retail outlet. William Hill is recorded as 'Aerated Water Manufacturer' in 1880, having works in 'Back Mostyn Street' (now Somerset Street). Yet his advertisements in the mid-1890s state that 'Perseverance Aerated Water Works, Llandudno' were established in 1867. This is a little confusing as in 1871 he lived in Salford. It all becomes more baffling as the date of 1876 is given for this establishment on his ginger beer bottle, but the water supply allegedly used by the works did not begin to operate until after 1880. The postal address for Perseverance Works is given as Salford House, Deganwy Street (now Avenue), where he made his home.

ESTABLISHED, 1867.
PERSEVERANCE
AERATED WATER
WORKS,
LLANDUDNO
PUREST AND BEST.

Manufactured from the famous Water procured from Lake Dulyn, opened by H.R.H the PRINCE OF WALES in June, 1880, and Certified by Dr FRANKLAND, the Eminent Analyst, to be equal in purity to LOCH KATRINA WATER

# WM. HILL,
POSTAL ADDRESS:—SALFORD HOUSE, DEGANWY STREET
## LLANDUDNO.

An 1895 advertisement for Perseverance Aerated Water Works, 'Established 1867'.

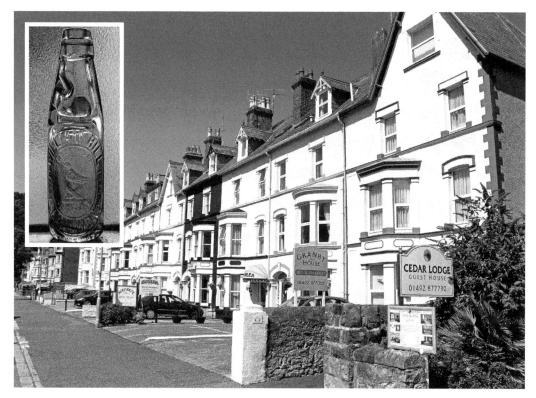

Deganwy Avenue. *Inset:* William Hill aerated water bottle.

William took part in the Grand May Day Procession of 1891, exhibiting his decked-out horse-drawn vehicles. Evidently the opening of summer was an important institution in Wales – the start of the tourist season. Lord Mostyn consented to act as president. It was a large and colourful affair with brass bands playing, showmen, processions, beer by the barrel and, of course, the inevitable performing dog. Local tradesmen displayed their stock and expertise and it appears that most of the businesses in town considered it important to take part.

By 1896 he had prospered: he was unanimously elected as president and secretary-treasurer of the north Wales Bottle Protection Society. The major concern of this fifty-strong society was to ensure that their bottles were returned to them. Losing the coloured-glass bottles embossed with their details was an expensive business. In 1899 the society expressed 'great pleasure' when 46,000 of them found their way back to its members.

T. Esmor Hooson's recorded links with Llandudno begin in 1878 when 'Hooson, grocer' attended a meeting held 'with a view to taking steps to assist the distressed people of South Wales'. He was one of the original founders of the Bottle Protection Society in 1892, the same year that his place of business was listed as 'Italian Warehouse, Mostyn Street'. In 1911 he is recorded as 'Grocer, Baker, and Mineral Water Maker' with an address at No. 96 Mostyn Street – this has been known as 'Hooson's Corner' since that time. He advertised that this business had been established in 1854; however, T. Esmor Hooson was born in 1851. The records show that he devoted much time to civic duties. In 1894 he was nominated as an Overseer of the Poor and in 1895 donated 100 loaves for the 'relief of distress' for the town's poorest families.

An Italian Warehouse had been set up in 1854, but on Church Walks facing down Mostyn Street. This, a forerunner to the modern department store, was run by Thomas Williams, a twenty-three-year-old chemist from Denbighshire; a year later he published *A Visitors Handbook to Llandudno*. By 1880 his chemist shop was at No. 75 Mostyn Street. The Italian Warehouse, renovated and extended, is now the Empire Hotel.

One business on the Great Orme, a farm whose origins go back some three centuries or so, capitalised on the prospects offered as an increasing number of thirsty English visitors

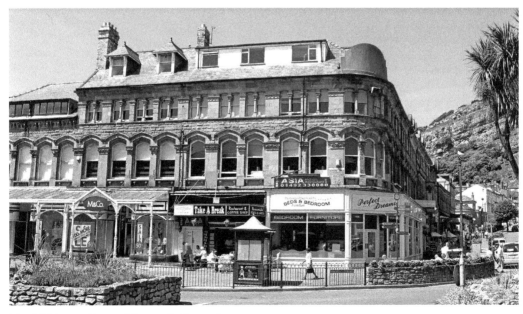

No. 96 Mostyn Street, 'Hooson's Corner'.

The Empire Hotel, formerly the Italian Warehouse.

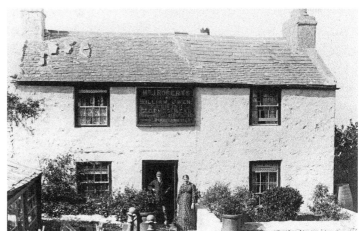

Farm Inn after 1894, with Jane and Robert by the door.

passed its door on their way to and from St Tudno's Church or straggled casually across the summit. William Owen was recorded at Penmynydd Isa in 1861 as a farmer of 30 acres. By 1880 the farm, now of 48 acres, was also an inn – Farm Inn.

William was born in Llandudno in 1808 and so witnessed the transition from the 'old' Llandudno to the 'new'. His farming activities included the keeping of geese, seventy of which were entered for the 'Christmas Show of Meat, Poultry, Game &c' in 1889, and donkeys – he came third riding one in the 'May-Day Inauguration of the Season' festivities of 1891. The residents of Penmynydd Isa in this year present a way of life in existence before the coming of the resort's visitors. While William, his niece and his daughter Jane with husband Robert Roberts were bilingual in Welsh and English, the three live-in servants spoke Welsh only and we can safely assume that Welsh was the living language of the hearth in Penmynydd Isa. We might guess it was for business reasons that the sign above the door was in English.

Jane (the inn) and husband Robert (the farm) took over Penmynydd Isa on William's death in 1894. In later years Penmynydd Isa continued its dual function as pub/café and farm, though not without meeting a problem common at this time: 1903 saw Mrs Roberts in court for serving warm milk laced with whisky on a Sunday. The farmhouse was beginning to be known as the 'Pink House' and later it transferred its business name to the 'Pink Farm Café' by which Penmynydd Isa was known into the modern period.

The King's Head.

The Snowdon.

There have been many pubs and inns in Llandudno town (there still are) where adult visitors can quench their thirst. The King's Head has been serving customers since at least the 1820s. It occupies a central place in the old village and for decades wages were paid out there, landlords and tenants met and other groups convened. The inn subsequently took on new roles; for example, after 1850 it became a venue for the sale and auction of buildings newly erected in the growing town. In this period being an innkeeper was not a male-only occupation: the King's Head's innkeeper in 1861 was Jane Davies; Grace Davies was 'Ale and porter dealer and farmer' at the now vanished Miner's Arms nearby.

Tudno Street was the first street built in the 'new' town, around 1850, and for the next decade was its commercial centre. By 1871 No. 12 had been converted from a private house to a public house, with James Davies as its landlord. No. 11 was subsequently purchased and the two combined to form the present building. Eight years after James had kept the premises as a beerhouse he applied for a licence to sell spirits as 'great inconvenience had been felt during the season because spirits were not supplied'. Unusually for this type of application the landlord had the support of the local Independent minister. Nevertheless the application was turned down and referred to the Brewster Sessions at Conwy.

The Cross Keys.

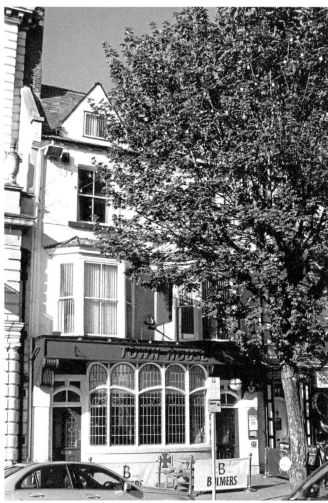

The Town House.

The sale at auction of the 'Cross Keys beer-house and vaults' in 1879 offers a snapshot of a local pub during this time. The leasehold of £2 per year dated from 1858. For this the successful bidder would gain 'a large front bar and vaults, with smoke-room adjoining, having underneath excellent cellarage: also, private entrance hall, dining-room, two kitchens, five bedchambers, scullery, wash-house and yard, with stable buildings in the rear, containing accommodation for two horses, with hay loft, on a back street'. The location on Madoc Street was stated to be in the heart of town amidst a 'constantly increasing population'. Historically it usually sold four to five barrels of beer a week: as a barrel then contained 36 gallons, nearly 1,500 pints were sold in a good week. The property sold for the reserve price of £35.

The Town House on Mostyn Street is another of Llandudno's older establishments. Its original name was the Tudno Vaults. The story of landladies comes full circle. Grace Davies who ran the Miner's Arms in 1861 took over the Tudno Vaults a year later; she was still running the establishment at over seventy years of age in the 1880s.

As well as somewhere to sleep, means of travel, entertainments and all the other expectations from being in a seaside resort, holidaying folk often want something to show others back home from their time away – so it was a good thing that photography was advancing technically and was becoming more affordable by the 1850s. As Llandudno became established it began to attract photographers, tempted by the prospect of setting up business in the growing resort town.

Thomas Edge was born near Preston, in 1820. In his early life he was employed as a 'Dandy Loom Weaver' in the cotton industry, but soon changed his line of work to that of 'Photographic Artist'. Within a few years his business had flourished and required the services of ten employees. Around 1880 he moved to Llandudno, with a studio at Nos 8–12 Gloddaeth Street. Here his business became a family affair: his wife Jane was 'Assistant Photographic Business' (we might picture her balancing the books), his son an 'Assistant Photographer', and his two daughters were the firm's 'Photographic Colourist' and 'Photographic Retoucher'.

Carte de visite (CDV) of a young girl for the family album by Isaac Slater, c.1880s.

*Above:* Once Thomas Edge's studio, now adorned with modern signage.

*Right:* Pyramids at Giza by Francis Bedford, 1862. (Courtesy of the Royal Collection Trust © Her Majesty Queen Elizabeth II 2017)

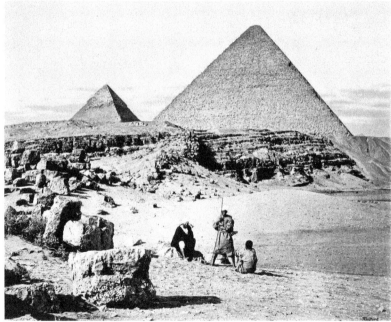

A photographer whose work on Llandudno is often encountered is Francis Bedford, though he resided in London. From the 1850s onwards he took photographs of landscapes and buildings throughout Britain. He also travelled much further afield – 190 magnificent photographs which he took when accompanying the Prince of Wales on a four-month tour of the Middle East in 1862 are now housed in the Royal Collection. Three years previously he had published photographs of Llandudno (*see*, for example, St George's Hotel, *above*) and would return many times thereafter. From its earliest days as a resort this photogenic locality had attracted the very best photographers.

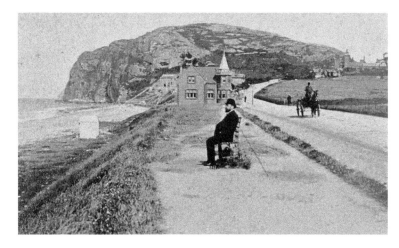

Photographer's
assistant at work.

The Camera
Obscura in its
lofty position.

Their assistants, though, were the true unsung heroes of early photography for it was they who had to hump around very heavy, cumbersome, but quite fragile equipment and assist in setting it up. They also had another, probably unexpected task to perform: sit in front of the camera to give the photograph a focus in the foreground, then pretend to be part of a 'Spot the Man in a Bowler Hat who randomly sits staring at nothing Competition' – because these (usually) chaps feature in many early photographs.

A quite different type of camera, and one invented centuries earlier, stands overlooking the town on Camera Hill: the Camera Obscura. This made its first appearance in 1860 and was the creation of Lot Williams, who was also Llandudno's first postman. The Camera Obscura works on the same principles as the pinhole camera though uses mirrors to project a 360° panorama of the town and bay onto a circular table. What must have been a wonder for those early visitors was destroyed by fire in 1966. It was rebuilt, first in 1994, then by the council in 2001 to commemorate the millennium.

# THE TOWN ESTABLISHED: 1900-39

At the dawn of the new century the resort had been evolving for fifty years. The town had matured in those years. Its infrastructure, travel links, hotels and guest houses, refreshment outlets, shops, tourist attractions and the many other features which embraced Llandudno were in place, all making the town a unique place to visit. Soon technological advances and events far away – some welcome, others decidedly not so – would produce new challenges and opportunities.

## POSTCARDS, CRAZES, AND KINGS

Picture postcards first appeared in Britain in 1894. As most showed pictures of places and were inexpensive they allowed the nation to see images of many parts of the country for the first time. By the turn of the century they were becoming something of an obsession: during the week of 21 August 1903 the craze was at such a height it was said that upwards of 90,000 had been posted in Llandudno alone.

One Llandudno resident (one of many), George R. Thompson, was quick to realise that an opportunity beckoned. Originally from Yorkshire, he came to Llandudno to work and by the turn of the century was a newsagent, stationer, and bookseller. He became known as 'The Postcard King of Llandudno' in 1903, publishing 200 or more new designs a month. His cards often carry a small portrait of him on the reverse, proclaiming his title (c. 1906–20). The first cameo is of King Edward VII, thereafter G. R. Thompson, gradually decreasing in size.

Though a printer by profession, his earlier cards can carry in the space for the stamp the information that they were 'Printed in Germany'. The First World War, which denied access to printing works in Germany, and escalating British costs were major factors in the decline of locally produced cards. By 1920 sending postcards had settled down to being just another thing one did whilst on holiday.

The carriage of mail switched from horse-drawn mail coaches to the railway when it began to spread its tentacle-like tracks across the land from 1830 onwards. It did not take long for the sorting of mail to take place not in post offices but in the trains themselves. In January 1861, Llandudno's post office became a Railway Sub Office. Up until that year Llandudno had obliterated stamps with a variety of circular postmarks. From 1861 it issued duplex

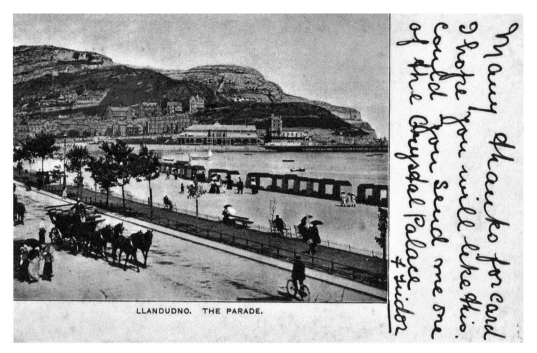

Posted in 1902, the message captures the postcard craze.

G. R. Thompson trademarks.

postmarks with Llandudno's unique letter/number identifier B47. They were last used in 1906 and by then the main post office had been located in Vaughan Street for two years. This grand edifice continued to serve Llandudno until October 2016 when post office services were relocated inside WHSmith in Mostyn Street.

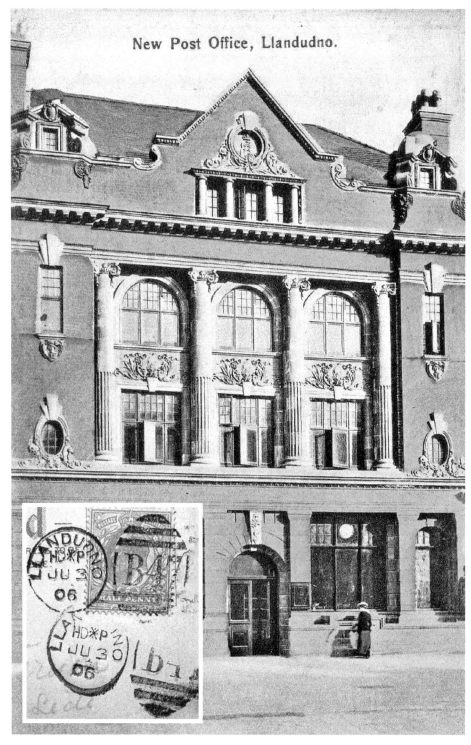

New Post Office, Llandudno.

Postcard of the new post office, 1904. *Inset*: Duplex Llandudno postmark. (© Royal Mail Group Limited)

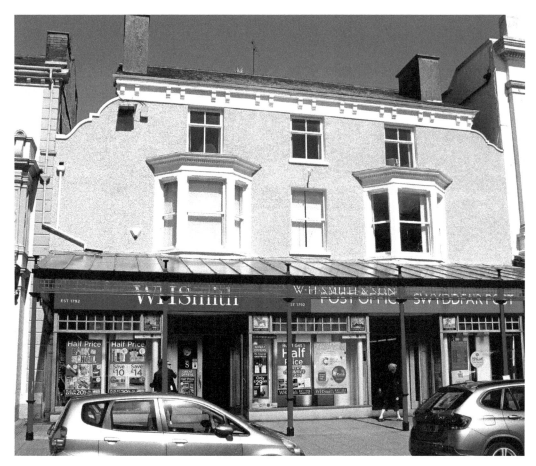

The Post Office, 2017.

# NEW WAYS OF GETTING FROM HERE
# TO THERE AND BACK AGAIN

The Great Orme and its natural beauty had been known from the late 1700s, but only for the fit and active. The 1890s witnessed proposals for several projects for the town in keeping with the changing times. One of these was for a tramway to take passengers to the summit. In April 1901 work began on its construction. In May the following year successful trials had been held and by July it was up and running – Britain's only cable-hauled public road tramway. Five months later in October Mr G. White, the manager, reported that 'upwards of 70,000 passengers' had already travelled on it.

This funicular system operates in two roughly equal halves. The lower section from Victoria Station has a gradient of 1 in 3.6 at its steepest. The driver, as most assume he is, is actually the Tram Attendant. His role is to communicate with the Track Winchman, of which there are two – one at the summit, the other at Halfway Station – using a system of buttons and lights to signal when to start, slow and stop the tram. The rolling stock, winding gear, cable, tracks and all other elements are frequently inspected. Other essential roles comprise the ticket

Not a race: Tram 4 ascending, Tram 5 descending, crossing at the midpoint of the lower section.

attendants, cleaners, maintenance staff, engineers and all those who work unseen ensuring the system is ready to receive 160,00 passengers each year.

Colwyn Bay is around 5 miles from Llandudno. However, those wishing to travel one to the other by rail before 1907 had to undertake a rather tedious journey via Llandudno Junction. Horse-drawn carriages were an alternative form of transport, but these were being overwhelmed by the increasing volume of traffic. The idea of bringing to Llandudno a form of transport already in use in other urban areas was being promoted in the 1890s. Many disputes later, the first tram on The Llandudno & Colwyn Bay Electric Railway line began its journey towards Rhos on Sea on 19 October 1907. The extension to Colwyn Bay opened the following year and it was soon realised that riding along the coast and over the Little Orme was an additional tourist attraction.

Problems began to be noted by the late 1930s. After 1945 these became more apparent: competition from motor buses and damage to the tracks and overhead lines caused by winter's high seas and gales were evident. The storms of 1952 and 1953 were particularly destructive and in 1954 the decision was made to close the railway and convert the service to motor buses. Although there were many objections to this, the service ran its last tram in March 1956.

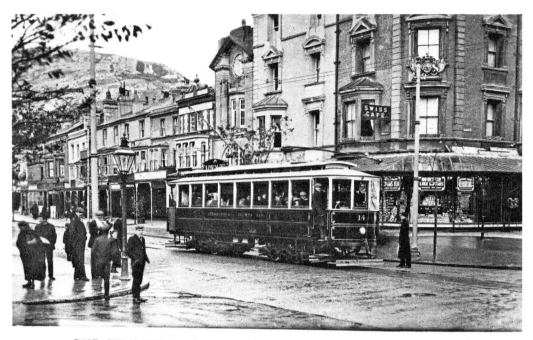

FIRST PUBLIC TRAM CAR. MOSTYN STREET, LLANDUDNO.
OCTOBER, 19TH, 1907.

Tram 14 making its first journey on a wet and windy 19 October 1907.

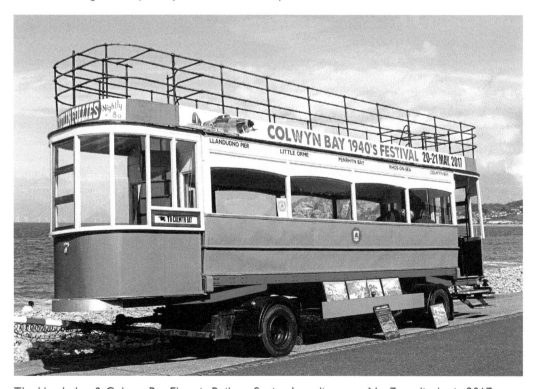

The Llandudno & Colwyn Bay Electric Railway Society's replica tram No. 7 on display in 2017.

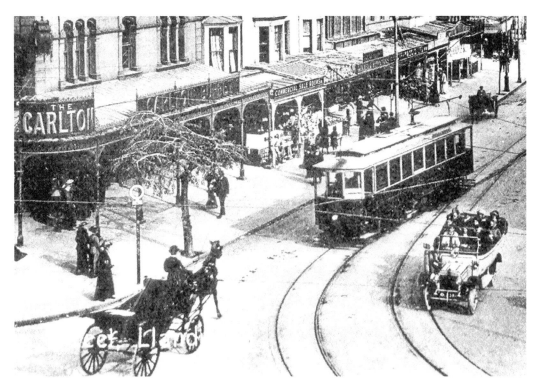

Transport old and new on Mostyn Street, c.1920.

Another newfangled machine appeared on the roads of Llandudno in 1907: the charabanc – a cross between a large car and a bus with no roof. Within a year a number of firms had sprung up taking tourists on well-trodden roads to places such as Snowdonia. Llandudno was being hailed as the charabanc capital of north Wales. One of these companies was Royal Red, whose main office on Vaughan Street was described as 'a specially-constructed wooden building painted a bright-red colour'. The company ran ten vehicles in 1920, undertaking twenty-two different tours: nine years later the number had risen to thirty with additional 'special inclusive holidays' to London and Scotland. The companies were now running trips over greater distances. Also growing was traffic on the roads, a concern to the Ministry of Transport. They conducted a census in 1922 and then in 1925, finding that the number of mechanically propelled vehicles on Conway Road had more than doubled in those three years.

Towards the end of the decade charabancs were being phased out in favour of 'sunshine coaches'. From this time on, especially after 1945, Llandudno catered to the holiday trade and was offering tours further afield for the general public. Other companies came to the fore and slowly amalgamated. Alpine Travel of Llanrwst was founded in 1972. In 1985 they acquired the rights to the Royal Red Tours brand name and in 1991 Creams Tours, another of Llandudno's oldest tour operators. A relatively recent development is for hotels owned by national chains to bring their clients to Llandudno by luxury coach, and then use this vehicle for day trips around the well-known beauty spots of north Wales.

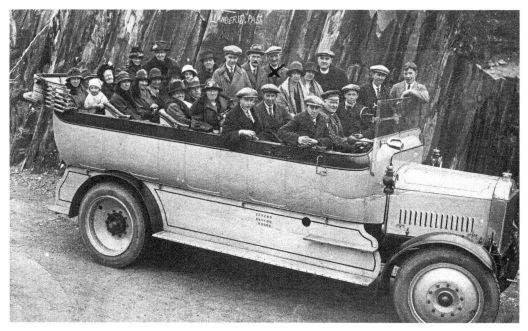

A Llandudno charabanc returning from Snowdonia, *c.*1922.

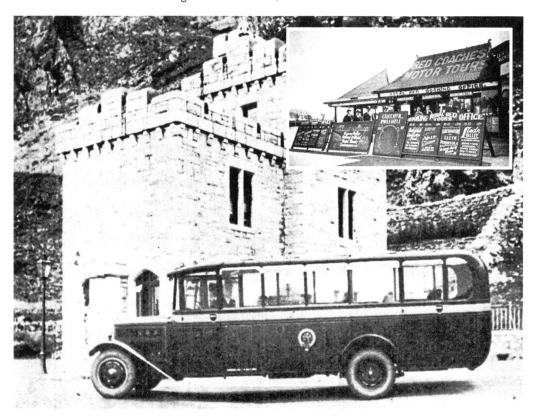

One of Royal Red's 'sunshine coaches' in 1929. *Inset*: Main booking office, Vaughan Street.

# CONVALESCENCE, CARE AND WAR

Llandudno's attractions were being increasingly noted far and wide. At Barrow in 1896 Alderman T. H. Thursfield reported that Lady Forester of Shropshire wished to use her late husband's bequest 'to build a convalescent home at some seaside place', and to this end had 'purchased a very fine site of 15 acres at Llandudno'. Lady Forester's Convalescent Home for sick and injured shale miners from Shropshire opened its doors on Queen's Road in 1904. Today it is one of the centres run by the charity Blind Veterans UK. This organisation, formerly St Dunstan's, dates back to 1915 when it was established to help soldiers who had lost their eyesight in the trenches of the First World War. It now offers support and rehabilitation for all members of the Armed Forces who have gone blind or are visually impaired.

The focus of the war effort in this part of north Wales was based either side of the Conwy estuary, on Conwy Morfa and at Deganwy with Llandudno Junction. The use of these sites as training grounds preceded the outbreak of war, and in 1915 they became permanent military training camps. Previously the men were housed in canvas tents, but as the nature of the camps changed so did the accommodation and wooden huts were built – whilst these were under construction the servicemen were billeted in private houses, including in Llandudno, which often amounted to little more than a mattress on the floor. An eyewitness in Llandudno in July 1915 noted that 'there are about 8,000 soldiers here. We saw the London Welsh parade this morning with the band and their mascot is a white goat'.

After the German invasion in 1914 many Belgians were evacuated to Britain. In October a train carrying eighty wounded Belgian servicemen arrived in Llandudno station. Waiting there was Llandudno's fleet of charabancs to transport them to Lady Forester's. The town's qualities and traditions as a centre for convalescence came to the fore during the First World War. The Red Cross ran many hospitals for wounded combatants across the country; by 1917 as well as Lady Forester's, the Balmoral, Bodlondeb Castle and Plas Tudno were home to some of these servicemen. Rather touchingly, in many group photographs from this period one or more patients are holding (cuddling) a small animal, usually a dog, sometimes a cat. 'Therapy pets' were aiding human recovery over 100 years ago.

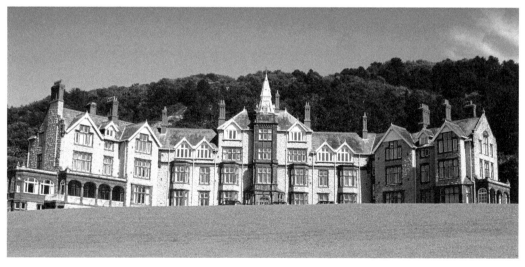

Blind Veterans UK centre, formerly Lady Forester's. (Courtesy of Blind Veterans UK)

On parade outside Elizabeth Villas.

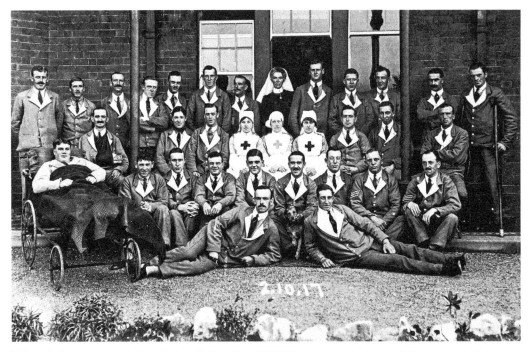

Wounded servicemen in Llandudno, 2 October 1917. The chap sat in front of the nurses holds a small terrier.

When the cheaper and easier to produce postcards became fashionable an element of the old CDVs survived – it was possible to have ones photograph taken for sending or giving to others. These became popular with servicemen: if they were never to return home at least there would be a memory of themselves for others to cherish. Sapper Walter Bruxby hailed from Kettering and in 1915 was posted to the Royal Engineer's Training Camp in Deganwy. He trained specifically on erecting pontoons, a purpose for which the Conwy estuary was well-suited. At some time he visited Llandudno and at Rowland's Studio on Madoc Street had his photograph taken and made into a postcard. He survived the war.

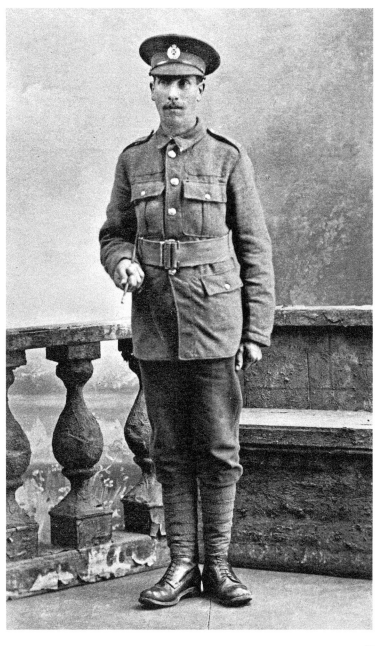

Sapper Walter
Bruxby.

# SERVANTS AND HOTELS

Together with other members of the 'lower orders' servants are largely invisible to history, yet in their time essential. In 1901 across the country 1.4 million domestic servants were recorded, and this number refers only to females in service. An interesting snapshot of the range of travelling servants is shown from 1861 when the Liddell family stayed at Tudno Villa on North Parade (now the St Tudno Hotel). The head of the family was Henry George Liddell, Dean of Christchurch, Oxford. He travelled with his wife and their five children, one of whom was eight-year-old Alice, later to be immortalised by Lewis Carroll for her adventures in *Wonderland* and *Through the Looking-Glass*. Their travelling retinue was a footman, lady's maid, nurse, nursery maid and governess – one servant each for the adults and three to look after the children.

After the First World War service was a declining industry; social conditions were changing and many new 'labour-saving' devices were beginning to appear. By 1921 it was reported that domestic servants of any description for hotel work were becoming scarce, even with high unemployment. A system of cooperation was initiated between hotel managers, Employment Exchange and railway companies to counter this difficulty. At the beginning of the year the group set out the potential need for staff and 'linked up' as the holiday season began – for Llandudno in the early 1920s the main supply area for its 'holidaymakers' servants' was Coventry and the Midlands.

By the 1930s the designation 'servant' for certain employment sectors was fading into the past. Nowadays 'hotel staff' is perhaps the preferable phrase. Though local people are employed the trend recently has been for employing workers from other countries – since the 1950s from nations such as Ireland, Portugal, Spain and Russia.

As the years go by hotels and guest houses can change hands for many reasons. They may be combined to create a larger undertaking, or the accommodation can be converted into private dwellings or offices. These factors and others lay behind a change in the number of smaller hotels and guest houses in Llandudno (though the number of available beds did not necessarily diminish). By 1880 there were at least 360 properties advertising for trade, but in 1918 this figure had halved. The Ambassador Hotel illuminates the story of five of them.

The selling of the new town in the mid-1850s offered individual plots. Five of these plots, situated on the corner of St George's Place and The Promenade, were bought individually and separate hotels were built. In time these were The Brinkburn on the corner, next door to the Tegwell on the Promenade. Along St George's Place were the Bodnod, Baldwin House and Glyn Isa. The Brinkburn was owned by Mr Underwood in the early years of the twentieth century. In 1918 he bought the Bodnod and merged it with the Brinkburn. After the end of the Second World War this concern was purchased by the Birchall family, who, in 1969, acquired the Tegwell Hotel. Further down St George's Place Glyn Isa was bought by the Richmonds in the 1920s, who renamed the establishment. With cash available they purchased the neighbouring Baldwin House in 1929, which then became part of The Richmond. Five had become two.

Meanwhile in the early 1920s a young lad was being somewhat economically creative. He met passengers off trains at Llandudno Station and offered (for a small fee) to carry their suitcases. His biggest wheeze though was when asked if there was anywhere good to stay he knew just the perfect place – his parents' bed and breakfast in the family home. The young lad was Fred Williams, who, after wartime service with the RAF, bought the Windermere Hotel in Craig-y-Don with his wife Freda. In 1958 they took a gamble and purchased The Richmond. Five became one in 1986 when the Williams family bought the Brinkburn, merged the two businesses, and named their new hotel The Ambassador.

St Tudno Hotel.

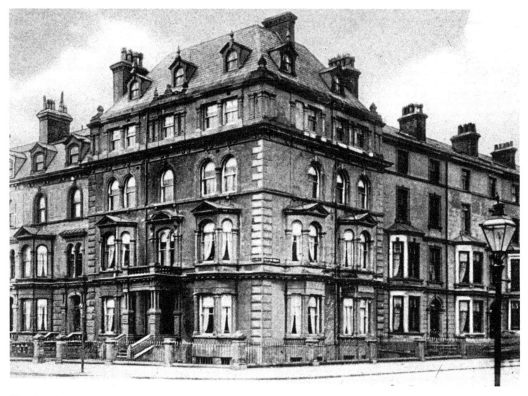

The Brinkburn Boarding Establishment, c.1910.

The Ambassador Hotel. *Inset*: Tidying the flower bed. Mr David Williams, owner of the Ambassador Hotel: 'There's not a job that hoteliers haven't done.'

# LLANDUDNO CONSOLIDATES ITS POSITION AS A MAJOR RETAIL CENTRE

Since the days of Isaiah Davies and Thomas Williams in the 1850s Llandudno was a place where careers could be made, if not fortunes. Robert Clare Baxter was one of many entrepreneurs attracted to the area. Originally from Runcorn, and born in 1883 into a family headed by his father, a steam engine maker, Robert turned in the direction of trade and became a draper's assistant on leaving school. It is said that his success and work ethic so impressed the owner of the shop that he was given £200 to start his own business. This he set up in Llandudno. Sometime between 1901 and 1911 he had become a Master Draper and Milliner with an address of Victor House, No. 39 Mostyn Street; he also had a shop in Craig-y-Don. Interestingly, in 1918 R. C. Baxter, draper, was operating out of a shop in Castle Street, Conwy. If this was the same person he was clearly making his mark. The photograph of Robert standing next to his vehicle dates from this period and it might be suggested that as well as running several shops he also took his wares around local markets.

Arthur's Pioneer Stores, a drapery at Nos 97–99 Mostyn Street, belonged to W. S. Williams of Llanrwst. In 1926 these impressive premises were put up for auction. The buyer was Robert Clare Baxter, who appears to have risked everything he had already built up to buy the shop and concentrate his energies on this venture alone. He soon set about rebuilding and modernizing the premises. To the frontage was added a façade in the art deco classical

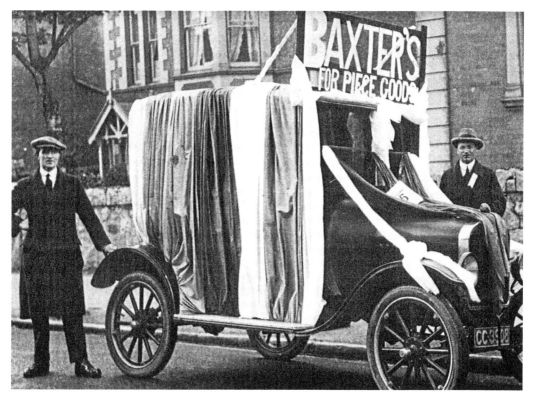

Robert Clare Baxter, draper and milliner, c.1920. (© Clare's)

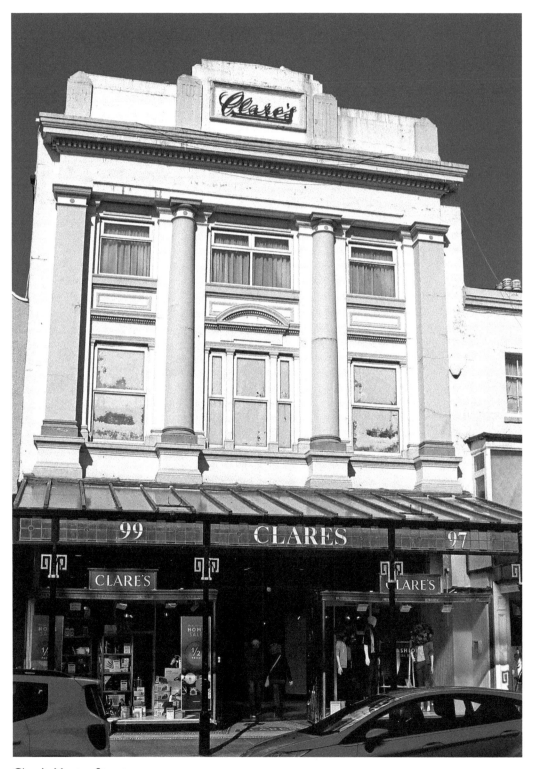

Clare's, Mostyn Street.

style, and internally an ornate iron cage lift and a pneumatic tube money transfer system were installed. His financial investment into this enterprise was impressive. He renamed it Clare's Modern Store, a high-class ladies' dressmakers and milliners. Other departments were subsequently added.

By 1935 his store was the place to dress queens. In that year Ethel Roberts was chosen as the Jubilee May Queen and her costume was designed and created by Clare's – and to the astonishment of staff Ethel came into the shop in 2007 on its eightieth anniversary with the original dress and receipt. Later in 1935 Nannette Fleet was chosen as Llandudno's Rose Queen and her robes were entrusted to Clare's to create also.

Rose Queen, 1935. (© Clare's)

# THE WAR YEARS: 1939-45

The war took many townsfolk to places far from home. Llandudno's cenotaph was unveiled in 1922 in remembrance of the casualties of the First World War, the 'war to end all wars'. The second set of bronze plaques attached just twenty-five short years later naming the fallen from Llandudno tell a rather different story.

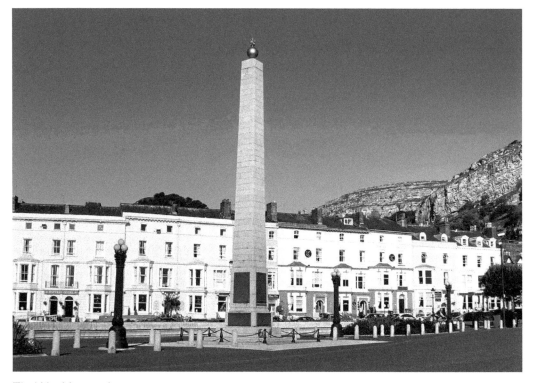

The War Memorial.

# THE HOME GUARD

After the evacuation of the British Army from the beaches of Dunkirk in June 1940 the German Army was almost in touching distance of Britain; invasion appeared imminent. Anthony Eden announced the formation of the Local Defence Volunteers on 14 May. A week after the announcement 414 Llandudno men had volunteered including 100 civil servants from the Inland Revenue. They were renamed the Home Guard in August by Winston Churchill.

This force was manned by those in reserved occupations – jobs considered important to the war effort – and by those too old or too young to be members of the regular army. The Llandudno headquarters were in the former Irish Linen Warehouse halfway along St George's Place, now the RNLI charity shop. They were formed into four companies, each with specific areas to patrol: 'A Company', the Great Orme; 'B Company', West Shore; 'C Company', Craig-y-Don; and 'D Company', Penrhynside.

If Britain had been invaded they had to be prepared to be the country's last line of defence and so underwent rigorous training in many areas including weaponry, scouting and camouflage, signalling and radio communications and dealing with perhaps the biggest perceived immediate threat, enemy parachutists. The battalion's training ground with its assault course and ranges for machine-gun and rifle practice was at Maesdu Farm. In addition to the basic *Home Guard Training Manual* a range of specific booklets were issued, one of which was the rather intriguingly titled *Rough Stuff for Home Guards*. Exercises were carried out from time to time to practise these skills. In one the Home Guard searched for 'enemies' who had infiltrated the town. Taking the role of the 'enemy' were members of the Royal Corps of Signals; those caught were taken to the town hall for interrogation. By 1944 the threat of invasion had lifted and the Home Guard was disbanded.

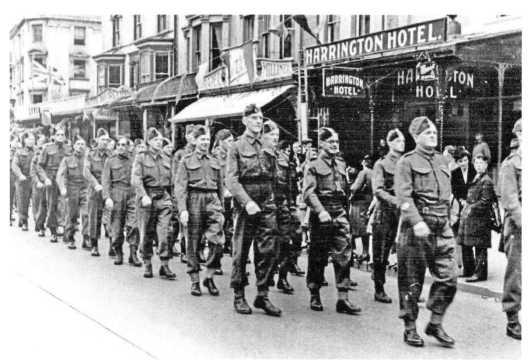

Llandudno's Home Guard, Mostyn Street. (Courtesy of Adrian Hughes)

Former Home Guard HQ, St George's Place.

# OUT OF HARM'S WAY

The threat of invasion and the bombing raids in 1940 made London and the south-east of Britain vulnerable to Hitler's forces. As a consequence much of the infrastructure of government and war transferred to less assailable locations, one of which was north Wales. It also possessed good accommodation in abundance. Much of Colwyn Bay was taken over by 5,000 civil servants from the Ministry of Food. A similar number of Inland Revenue staff, together with their families, were welcomed in Llandudno over the months of 1940. What these folk thought of leaving their homes is not clear, though a reputable source has reported that some who came up from London were quite surprised to see that the roads around these parts had been made up and were not mere dirt tracks. The government requisitioned over 400 private residences, boarding houses, guest houses and hotels for their use as accommodation and office space.

The Inland Revenue was composed of many separate departments. The Assessments Division and the Companies Registration Office (otherwise known as Companies House) were based in the Grand Hotel. A different branch operated out of the Imperial Hotel. One of its employees was James Callaghan, Prime Minster (1976–79). He was Assistant Secretary to the Inland Revenue Staff Association. Part of his role was to arrange accommodation for those who were transferred to the town. Further duties included Entertainments Officer and overseeing the setting up of a recreation centre for staff and families at the Ormescliffe Hotel. With this background we might assume he had an intimate knowledge of the town.

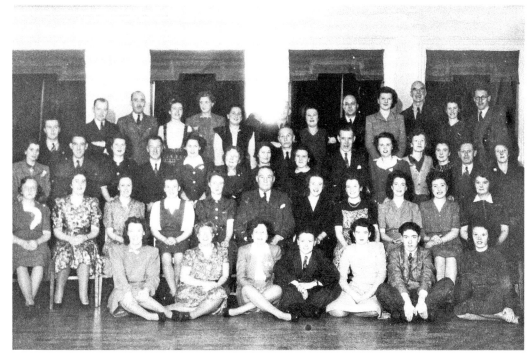

Inland Revenue Assessments Division staff in the Grand Hotel. (© Charles Eaves)

Though they had their own facilities the Inland Revenue staff immediately joined in with Llandudno's established community. The war years were austere with rationing and many of societies' accepted pleasures were on hold. Furthermore, no one knew when the war would end. To counter this Llandudno's new residents put on amateur theatre productions, joined in with the town band and organised parties for local children at Christmas.

The Royal Artillery's Coast Artillery School at Shoeburyness in Essex was also vulnerable to enemy action and had to be relocated to a safer place, one where target vessels could be anchored offshore and conditions were good for directing ships by radio. With the Conwy estuary to the left and the Menai Straits ahead the western slope of the Great Orme was the ideal location. The school moved in September 1940; the layout of the site was planned in just one day by the Royal Engineers, using toy balloons bought locally as site markers. In addition to the gunnery wing, wireless and searchlight wings were established, and so began the training of officers and other ranks in the art of coast artillery and radar technology. At its peak in 1942, 150 officers, 115 cadets and 445 other ranks could undergo training. Across on the Little Orme a coastal artillery practice camp was established. With such a contingent of trainees and permanent staff many buildings around town were commandeered. Gogarth Abbey Hotel (now demolished) became the headquarters and senior officers' mess with junior officers in the Richmond (now part of the Ambassador Hotel) and White Heather Hotels. As with the incomers from the Inland Revenue, the school's staff joined in with local activities, including staging variety shows and partaking in sporting events. They also cooperated in joint exercises with the Home Guard and the RAF, who had a radar installation on the summit.

Finally, after six long years the war was over. The artillery school was abandoned and the hotels returned to civilian use.

Three traversable searchlight positions.

# THE HOME FRONT EXPERIENCE

Liverpool was enduring another night of incessant bombing raids; the Blitz was at its most devastating and the city was ablaze. A stray incendiary device hurtled earthwards, crashing on the driveway. It was 1941 on the Wirral. Next morning the remains of the bomb were discovered just feet away from the house – luckily it had caused no damage. Decades later an eight-year-old boy at his grandparents' home became fascinated with these fragments and the many and personal stories which lay around them. By 2000 the fascination – and collection – had grown. It was time to launch the Home Front Experience.

The building that houses this collection has its own wartime connections. From it in 1919 Frank Meredith set up a garage and taxi company. Frank had served with the Royal Field Artillery during the First World War. In 1940 part of the building was taken over by the Auxiliary Fire Service – a pump and trailer were kept here, manned by twelve volunteers. As fate would decree, this was taken to Liverpool to help dampen the fires of the 1941 Blitz. At the end of hostilities a colourful, loud and large party engulfed Taliesin Street where Patricia Meredith was crowned its 'Victory Queen'. By around 1960 the Merediths had closed the garage and it passed through several hands until acquired by Adrian Hughes in 1999.

Though a museum – it houses artefacts and ephemerae from the Second World War – its attraction is encapsulated in the word 'Experience'. A leisurely self-guided tour around the exhibits reveals civilian life on the Home Front: a wartime kitchen, a sweet shop, the police station, gas masks for adults and children, ration books for everyone, an Andersen air-raid shelter, a land girl with farm implements, pamphlets advising 'how to grow your own', a schoolroom, contemporary newspapers, a pharmacy and many other displays depict Britain during those years. For some visitors these are nostalgic memorabilia; for others of all ages they offer a fascinating glimpse of living history when the country endured – and survived – 'its darkest hour'.

The Home Front Museum on New Street. *Inset:* The fragments of the incendiary bomb.

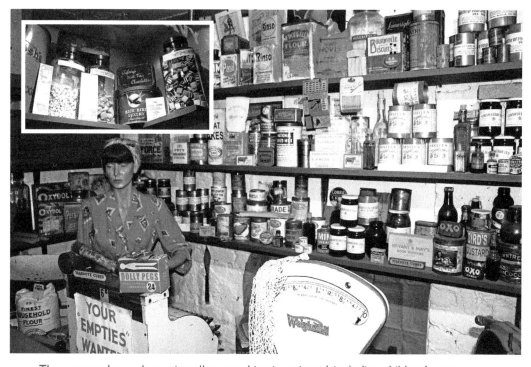

The corner shop, where virtually everything is rationed, including children's sweets.

# AFTER 1945

Llandudno entered a period of austerity after 1945, as did the rest of the country. However, the town's facilities and traditions enabled it to re-establish itself relatively quickly. As the twentieth century passed and became the twenty-first, modern amenities supplemented those of an earlier age. Llandudno was again consolidating its position as north Wales' premier tourist destination.

## RETURNING TO NORMAL: THE IMPERIAL HOTEL

The Imperial Hotel was created in 1872 by the merger of several boarding establishments. It housed a section of the Inland Revenue from 1940 to 1945. At the end of hostilities these departed and business resumed. Men were returning home to Llandudno, but rationing remained a way of life. Notwithstanding the latter problem the staff football team was quickly reformed and a fine Christmas spread was prepared in the kitchens, all under the watchful eye of Mr Cox, the general manager. Life had started to return to normal.

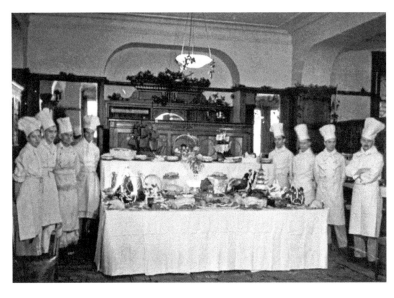

The Christmas spread, 1946. (© Imperial Hotel)

*Right*: General
Manager
Mr Eric L. Cox
and chiefs of staff.
(© Imperial Hotel)

*Below*: The
Imperial Hotel.

# COMBINING THE OLD WITH THE NEW

The first place of entertainment to open in Llandudno was St George's Hall, in 1863. This put on shows and recitals in keeping with its period and clientele. In the year after it opened a grand concert was performed under the baton of Mr John Handel Jones. A year later Mr Beaumont read the tragedy of *Romeo and Juliet* to a 'fashionable and numerous audience'. It was also the venue for endeavours which we might not consider to be theatrical: it was the setting for Divine Worship and for raising funds for the lifeboat. Towards the end of the century it was staging vaudeville. The popularity of stage shows resulted in the Pavilion at the landward end of the pier opening in 1884, followed by the Arcadia (1894), Grand Theatre (1901), Savoy Cinema Theatre (1914), Palladium (1920) and the Winter Gardens Theatre, Cinema and Ballroom (1935). Each put on a variety of shows, though a stipulation when the Grand Theatre was built was that it should never perform Music Hall material. Llandudno attracted well-known performers such as Sir Malcolm Sergeant and Sir Adrian Boult, who both conducted the orchestra in the Pavilion. This auditorium had a further role accommodating political conferences, and over the years received many well-known attendees, including David Lloyd George, Ramsey MacDonald, Neville Chamberlain and Winston Churchill.

By the mid-1930s tastes were changing. Cinema was entering the age of the talkies and slowly over the years, as radio gave way to television and gramophones, the type of offerings blended with the times and performers, such as George Formby, Jimmy Edwards, Russ Conway, the Beverly Sisters, Cliff Richards, the Welsh National Opera and perhaps, most famously, in August 1963 at the Odeon (formerly the Winter Gardens), the Beatles. By now newer technologies and different forms of entertainment were taking away audiences and gradually these performance spaces fell out of favour and went out of business – St George's Hall in 1957, Grand Theatre (1980), former Winter Gardens (late 1980s), Savoy (1987), and the Arcadia (1992). The Pier Pavilion was destroyed by fire in 1994 and the Palladium closed its doors in 1999.

However, new developments were soon afoot on an old site. The Arcadia started out in 1894 as the Victoria Palace, originally intended as a temporary structure across from a never-built second pier serving Craig-y-Don. It passed through a number of name changes as its fortunes and function changed. It became Rivière's Concert Hall in 1895 and after a brief spell as the Llandudno Opera House it became the Hippodrome in 1900. During the summer months it operated as a concert venue, but in winter was used either as a ballroom or as a skating rink. Theatre impresario Will Catlin bought the theatre in 1915, renaming it the Arcadia a year later, and it became the home of Catlin's Pierrots, soon to be known as Catlin's Follies. As a traditional seaside entertainment venue it flourished. Its founder died in 1953 and the show was run by his family. It was bought by Llandudno Urban Council in 1968 but with audiences dwindling it closed in 1994. The theatre lay derelict and abandoned until 2005 and was then demolished.

Meanwhile, next door, the Aberconwy Centre, where conferences for as many as 1,000 delegates could be held, had opened in 1982. This was extended – with a 1,500-seat auditorium and facilities to stage the largest of West End productions – and renamed the north Wales Theatre and Conference Centre in the year the Arcadia closed. This in turn was redeveloped and enlarged in 2005, on the site of the now demolished Arcadia. Probably to the delight of hotel and guest house owners the capacity of the conference centre became 5,000. In 2007, after a public competition, the complex was renamed Venue Cymru, its theatre staging top-class productions. Showtime was back in Llandudno town.

The Grand Theatre.

In the late 1950s Glasgow-born Alex Munro settled in Llandudno after a very successful music hall career. He and brother Archie (The Horsburgh Brothers) began as acrobats while still boy scouts, and later became part of Florrie Forde's music hall company, which included Bud Flanagan and Chesney Allen. He toured throughout Britain and, in his own words, 'played all

Venue Cymru.

over the world'. In the war years he entertained in many towns and cities with the RAF show *Contact*. During this period he hosted and starred in his own BBC radio series *The Size of It*.

Alex Munro will be fondly remembered for his variety shows in Happy Valley. For over twenty-five years these were a major success and the highlight of many a visitor's time in the town. In the 1970s he was given creative control of the Pavilion Theatre with its summer entertainments and, during the winter months, a pantomime. The shows presented in both venues were firmly family-oriented; indeed they were designed to be so. In a newspaper interview around the late 1970s Alex laudably deplored the creeping influence of vulgarity in family shows. Perhaps therein lies a problem: times and tastes – often film and television led – were changing and by the mid-1980s the Happy Valley show ran one last time. An era was over. Alex Munro has been honoured twice by Llandudno: in 1982 he was presented with the Llandudno Coat of Arms award and in 2014 the road leading from the Grand Hotel up the hill to Happy Valley was named 'Alex Munro Way'.

Over the decades the resort had forged for itself an additional role to that of tourist destination and one probably not foreseen by its founders: it became a 'central place'. The town's retail and commercial outlets were originally set up to serve the tourist industry and local residents, but gradually a range of specialist shops emerged selling merchandise not found elsewhere in the district. It had become the destination of choice for customers seeking to acquire specific, high-quality, professional products and services.

Cameo Brides began as a dedicated bridal shop on Madoc Street twenty-five years ago and has been on Vaughan Street since 2014. Brides-to-be chose their outfit and accessories for the day and often those for their bridesmaids. Customers come not just from the town itself but from the wider local area, Wales as a whole, and from nearby England through

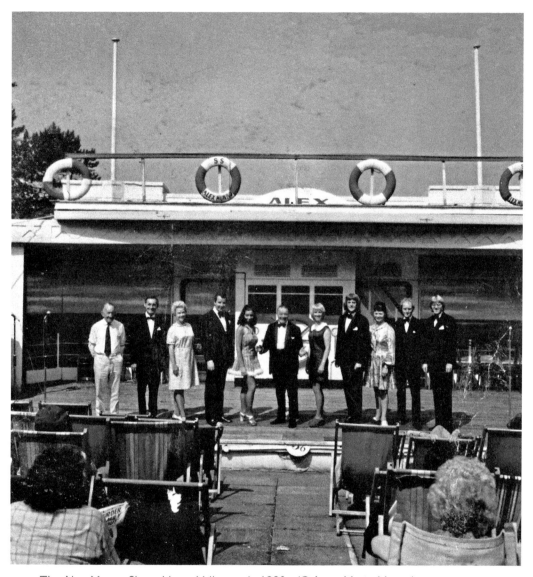

The Alex Munro Show, Happy Valley, early 1980s. (© Anna-Marie Munro)

'footfall', personal recommendation and via advertising media, and also as tourists to the town, returning nearer the day to pick up their order from Llandudno.

In a book detailing the history of Llandudno and those who have worked here, mention has to be made of Conwy Archive Service based in the old Llandudno Board School (built in 1882). This service aims to gather records of value for the county borough, to conserve them and make them freely accessible for those with an interest in our past. A diverse range of material is held, much of which is catalogued, and includes documents, photographs, maps and plans. A digital record of more important holdings has been undertaken – and continues to be added to – covering subjects such as churches, schools, local government, clubs, businesses and personal records from individual members of the community.

Cameo Brides, set elegantly in Vaughan Street. *Inset*: Rosie displaying a bridal gown.

Conwy Archives.

# FURTHER FUN AT THE SEASIDE

Llandudno Museum is unusual in that it is not administered by the local authority or a local university but by the Chardon Trust. It was established first at Rapallo House in Craig-y-Don on the death of the owner, Francis Edouard Chardon (1865–1925). His bequest to the town included the building and a magnificent collection of paintings and artefacts from around the world as well as an entire traditional Welsh kitchen. Born in India, the son of a wealthy indigo merchant, he travelled widely, and his collection mirrored this background. The museum has occupied the present site on Gloddaeth Street since 1995.

The museum's holdings have been greatly augmented since Chardon's day and new material continues to be added, illustrating the development of Llandudno and its hinterland from prehistory up to recent times. Unexpectedly, also on display is a complete suit of armour made for a Japanese samurai warrior, which was presented to the Prince of Wales in 1922. Many wonderful paintings adorn the walls and much of interest can be discovered in display

cabinets. Children and schools are particularly well catered for. With recent grant applications and positive planning, an extension to the museum is imminent.

On summer days when the air is still, cable cars glide between the bottom of Happy Valley and the summit of the Great Orme. For over eighty years cables had pulled trams up to the summit. In 1969 cables of a different sort helped transport passengers on the longest aerial cabin lift in Britain. The novelty of the experience was such that Pathé News filmed Lord Mostyn and John Prestland, project manager, climbing aboard one of the cars and riding to the summit. The newsreel also showed the winding gear, electric motor and cable arrangement which drive the mechanism. The journey takes around nine minutes to cover the mile or so between the termini and soars at its highest point 80 feet above the ground, allowing for splendid views of the Orme, the Conwy estuary, the town and bay with the Little Orme in the distance.

The old and the new come together on Wyddfyd Road at the top of Happy Valley. A renovated farm cottage overlooks a Swiss chalet-style café, restaurant and bar, which itself sits aside a 300-metre dry ski slope and a 700-metre toboggan run. The centre, which also offers snowboarding, tubing and golf, opened for business in 1989. This facility expands Llandudno's attractions and, as with other innovations on the Orme and elsewhere, helps present a wide and varied experience for visitors.

Country Parks developed in Britain following the passing of the Countryside Act in 1968. Essentially this provided for easy access to the outdoors over a particular defined area. Though these parks are not necessarily areas of natural or historical conservation, they often include such features. The Great Orme has both aplenty and has been designated as a Special Area of Conservation, a Site of Special Scientific Interest and a Heritage Coast. Since 1986 it has fulfilled a dual role being managed as both a Country Park and as a Local Nature

Llandudno Museum. *Inset*: J. C. Chardon. (Courtesy of Llandudno Museum)

Traditional Welsh kitchen. (Courtesy of Llandudno Museum)

Cable car near the lower terminus, passing Pen Dinas.

Dry ski slope.

Reserve, overseen by Conwy Countryside Service and administered by the park's rangers and volunteers.

In May 2015 the National Trust acquired for £1,000,000 grazing rights to 720 acres of the headland and the 140-acre Parc Farm in order to help protect the habitats of unique and rare species of plants and animals. In October 2016 Dan Jones leased the farm from the National Trust for a rent of £1 a year. This land is home to 360 species of native wild flowers, including nearly twenty which are rare and threatened: the Great Orme Berry occurs nowhere else. Rare lichens and mosses can also be discovered, as can a multitude of butterflies. It is also a notable bird-watching hotspot. The new tenant brought traditional sheep-herding techniques to the farm and his 400-strong flock now help with the conservation of these and many other species and the ecological base of the landscape which supports them all.

Providing guidance to the many thousands who visit the Orme each year is the Visitor Centre, situated near the summit. The building itself is unusual in that it is self-sufficient in energy, powered by fifty-six solar panels. Inside, displays and interactive presentations describe how the headland came into being, its geology, the thousands of years of its history, and the flora and fauna which inhabit the land, the cliffs and the surrounding sea. A live webcam feed looks in on seabirds. Guided tours are arranged from the centre. For schools, country park staff offer an 'Environment Activity Walk'.

The Great Orme Visitor Centre. (Courtesy of the Great Orme Visitor Centre)

From the early days the beach and promenade have been the setting for many and varied events and attractions, some organised, some less formal, and a smaller number being consequent to other activities. In the modern era, with changing fashions and ideas, new performances and displays have attracted spectators and participants. Charity runs are a regular feature, as are music events. The Llandudno Arts Weekend with its eclectic programme running in many venues around town includes dance, theatre, music, artists and displays on the promenade. Classic cars and the Honda Goldwing Parade grace the promenade annually. The display on bonfire night attracts thousands to enjoy the sight of a fantastic variety of fireworks lighting up the bay. Also in November Remembrance Sunday is perhaps not an event such as those just mentioned but is a special part of the year. On the beach activities such as windsurfing and Llandudno's Sea Triathlon race have joined the more traditional sandcastle-building and sunbathing. During the summer it is also home to various fun events.

The town has always attracted new ventures. One of these is Bodafon Farm Park, a site of 16 acres leased from Mostyn Estates. Bodafon Hall Farm is recorded from the sixteenth century. In the mid-nineteenth century it was home to John Williams, the company secretary for Tŷ Gwyn copper mines and land agent for Mostyn Estates, a prominent player in the early development of Llandudno. In his day the main farm comprised around 250 acres with three tenants farming small acreages, all of whom carried out mixed farming. A later owner, for a cost of £200 in 1889, was Evan Jones, who had argued successfully in 1878 that carriages of all types be allowed to transport passengers around the newly constructed Marine Drive. He also ran tourist coaches to Snowdonia and the stabling block was an important part of his holdings. As well as horses the farm possessed a dairy herd requiring the services of two live-in 'milk boys'.

What would the Victorians have thought of this gathering? Honda Goldwings on the promenade.

Fun with the Beach Team.

Nowadays Bodafon Farm continues these working practices and visitors can appreciate animals which are usually seen as specks in a distant field. In addition to cows and sheep the farm is home to a donkey, pigs, geese, ducks, goats, horses, the very friendly resident farm dogs and more unusual animals such as llamas, red and fallow deer and Highland cattle – most of

Horses at Bodafon Farm.

who will gladly be your best friend for suitable titbits of food. Visitors can dine either in the restaurant (which also hosts musical events on summer evenings) or seated outside the café. There are many farm-related activities for children which offer a different type of fun and educational experience than they might normally encounter.

A further attraction of the Farm Park is its association with the Owl's Trust. This charity endeavours to rescue and rehabilitate sick and injured wild birds, mostly owls but occasionally other birds of prey. The sanctuary is home too for captive-born birds who were previously neglected or kept in unsuitable conditions. Alongside this work the trust runs a breeding program that aims to help protect threatened species from around the world. All these birds can be observed happily housed in appropriate enclosures behind the farm buildings.

For millennia something which was to become world famous lay deep underground. Miners in the nineteenth century had broken through into old workings, but as was common at the time, old meant Roman and in the grand scheme of economic necessity remained a minor curiosity. The upper section of the tramline across the Great Orme was built through a scene of industrial dereliction, the nineteenth-century surface workings and spoil heaps surrounding Vivian's Shaft. In 1987 the decision was taken to turn this eyesore into a car park.

After the first nineteenth-century mineshaft had been exposed engineers, archaeologists and members of the Great Orme Exploration Society inspected what lay below ground. They discovered a labyrinth of passages and tunnels and – most unexpectedly – thousands of ancient mining tools. The Bronze Age copper mines had been discovered.

A llama with her newest best friend. Deer are looking on. (© Bodafon Farm Park)

The restaurant with indoor and outdoor seating areas. (Courtesy of Jenni Morgan)

A great grey owl scrutinises the photographer while a barn owl has a snooze. (Courtesy of Jenni Morgan)

The car park scheme was abandoned and over the next three years a thorough survey of the site was undertaken, with a view to opening it to the public and using the proceeds to fund further archaeological excavation and research. Great Orme Mines Ltd was formed in 1991, and a year later the first visitors arrived at the site. Since that time surveying and excavating has continued, with new discoveries being made. Facilities for visitors have also been enhanced over these years. Information boards help describe the site, walkways and bridges have been built and mine passages made safe and well lit. The visitor centre, extended in 2014, exhibits a selection of mining tools and bronze axes and offers information about the mine. Education has become an important aspect of the work carried out here also, and schools and groups visit for a guided tour of the workings, with all its aspects described and explained.

New discoveries await in and around the world's largest Bronze Age mine, one of the country's most important archaeological sites. Llandudno has a long and varied history.

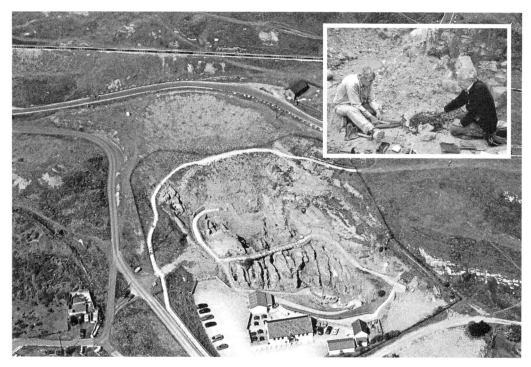

Aerial view of the site. *Inset*: Experimental archaeology: assessing Bronze Age smelting techniques. (Courtesy of Great Orme Mines)

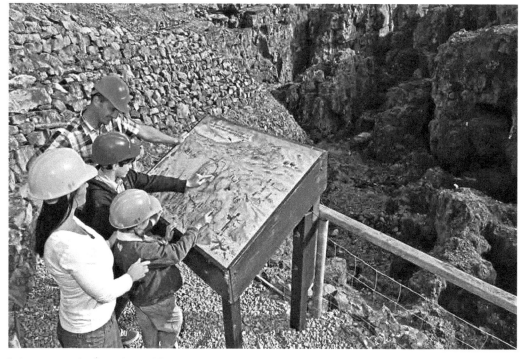

Information always at hand. (Courtesy of Great Orme Mines)